IMAGES
of America

GARFIELD

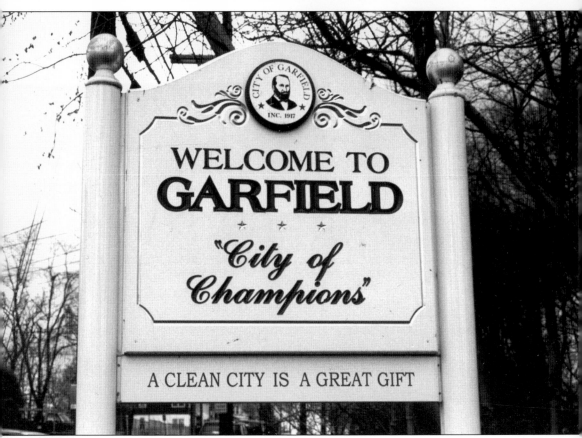

This book is dedicated to all historians and societies of local history who, at times, strive against great odds in order to research, record, and preserve their history.

IMAGES
of America

GARFIELD

*To Roger
with very best wishes.
Howard Lanza*

Howard D. Lanza

ARCADIA

First printed in 2002.

Published by Arcadia Publishing,
an imprint of Tempus Publishing, Inc.
2A Cumberland Street
Charleston, SC 29401

Printed in Great Britain.

Library of Congress Catalog Card Number: 2002106505

For all general information contact Arcadia Publishing at:
Telephone 843-853-2070
Fax 843-853-0044
E-Mail sales@arcadiapublishing.com

For customer service and orders:
Toll-Free 1-888-313-2665

Visit us on the internet at http://www.arcadiapublishing.com

CONTENTS

ACKNOWLEDGMENTS

There are certain people whose contributions made this work possible. Thanks go to Elizabeth Gray, Garfield city historian, and to all of the members of the Garfield Historical Society for having the foresight to gather and preserve many of the photographs and historical data from the city's early years. Special thanks go to society members Mark Pedone and Dan Palubniak for helping with histories of the police department and the local textile industry. The author is also indebted to those who served as consultants and to those who donated or loaned photographs to be included in this edition: Frank Monash, Robert Scussel, Mark Auerbach, the Forstmann Library, Michael Ferenc, Drew Pavlica, Thomas Zangara, John P. Logan, Walter Nebiker Jr., the Garfield Messenger, and the police and fire departments. The author is also grateful to all those who donated any photographs or memorabilia to the Garfield Historical Society over the years that may have been incorporated into this book. Special gratitude is extended to Eugene DiBella, Maryann Romanchick, and Paul Staudt Jr. for proofreading and commenting on the text and to Joseph Siuta for his expert guidance with the photography.

INTRODUCTION

Garfield is situated on the east bank of the Passaic River opposite the cities of Passaic and Clifton. Its southern boundary conforms to the winding of the Saddle River. At the east, the borough of Lodi and Saddle Brook Township abut Garfield. The borough of Elmwood Park and another part of Saddle Brook Township lie along its northern border.

The earliest recorded settlers in what became Garfield included Cornelius Van Voorst, a lieutenant colonel in George Washington's army; Andrew Zabriskie, whose grandson Christian built a home, gristmill, and general store near the junction of the Passaic and Saddle Rivers; Adrian Post, who operated a gristmill and sawmill near Toer's Lane (Outwater Lane); and James Cadmus, who purchased the Zabriskie land and established his locally famous Melon Patch.

During the Revolutionary War, on November 26, 1776, a British raiding party invaded one of the few scattered farms that existed in Garfield at the time, that of John Cadmus. His slaves were released, 12 horses were taken, and supplies and produce were pillaged from the farm and house. Cadmus and his son-in-law David Marinus were captured and taken to the old Sugar House prison in New York City. That evening, 10,000 British and Hessian soldiers forded the Passaic River from the Garfield side at Post Ford in pursuit of Washington's army.

At the time, overland travel in Garfield was completed on the area's three dirt roads: Slaughterdam Road (River Drive), which ran north and south along the Passaic River; Toer's Lane (Outwater Lane), which ran east and west from what became Garfield to Hackensack; and Bear's Nest Road (Midland Avenue), which connected the villages lying north and south.

The founding of modern-day Garfield is credited to Gilbert Ditmus Bogert, who in 1873 purchased the farm of John Barkley and laid out the village of East Passaic. His vision was to create affordable building lots for one- and two-family homes (each with a yard and garden) that would be within walking distance of the factories in Passaic. In order to increase potential development, Bogert's East Passaic Land Company built a bridge at Monroe Street and erected seven houses before the financial panic of 1873 interrupted the project. However, within a few years, the resilient Bogert recovered his losses and once again pursued his dream to build a suburb of Passaic. He later established the Bogart Land Company and proceeded to develop the lower section of Harrison Avenue, which became known as Bogart Heights.

James A. Garfield became the 20th president of the United States in 1881, the year the Erie Railroad added the Bergen County Short Cut line and erected a depot at the corner of Midland Avenue and Passaic Street. A short time later, the New York, Susquehanna, and Western

Railroad created a line at Passaic Junction near the foot of Belmont Avenue that extended to the mills in the Dundee section of Passaic.

The two-square-mile area in Bergen County that makes up present-day Garfield was originally a part of Saddle River Township, until March 15, 1898, when it broke away to become an independent borough, governed by a mayor and council. On April 19, 1917, the borough became the city of Garfield. During those 19 years, its population had grown from 3,000 to about 18,000.

The availability of waterpower from the Passaic River and the establishment of railroads soon attracted large industry to build factories—first in Passaic and Paterson, then in Garfield. The need for workers in the mills led to the arrival of great numbers of European immigrants, which initiated the largest population and business boom in the history of Garfield. Churches were established with services in languages such as Polish, Italian, Slovak, and Russian. By 1920, Garfield had a population of 19,381 residents and 56 industrial firms, making it the largest manufacturing town in Bergen County. Major innovations in food packaging, textile, paper recycling, and embroidery were made in these early mills.

Although the old mills have closed and many residents now work outside of town, Garfield remains an active community that continues to develop, constantly adjusting to changes in its socioeconomic makeup. It is hoped that this book will inspire memories and discussions that will disclose additional information and a greater understanding of our city's heritage.

One

EARLY HISTORY

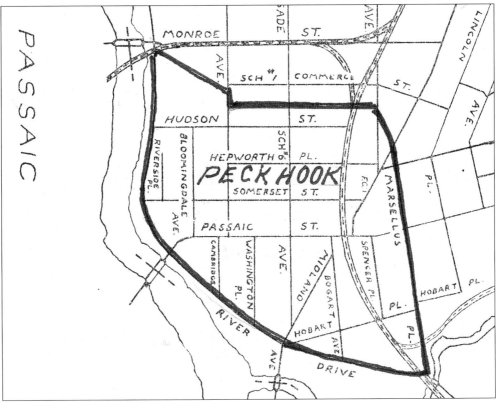

Shown in this map are the boundaries of Peck Hook, a section that was founded in 1722 by the Dutch in what is now Lodi. The name was derived from that of Native American Chief Paaket (pronounced Packook), who lived near the Saddle River Bridge. Later, the Zabriskie family operated a gristmill at the junction of the Passaic and Saddle Rivers. A fire company, municipal hall, police headquarters, post office, church, school, and various forms of commerce were all first established in this section.

On January 1, 1873, Gilbert Ditmus Bogart, the founder of Garfield, and his associates formed the East Passaic Land Company and purchased John F. Barkley's property on River Drive between Monroe Street and Van Winkle Avenue. The company had built the first bridge to Passaic, the Monroe Street Bridge, and had erected seven houses on the land before the great financial panic of 1873 temporarily halted plans to develop East Passaic.

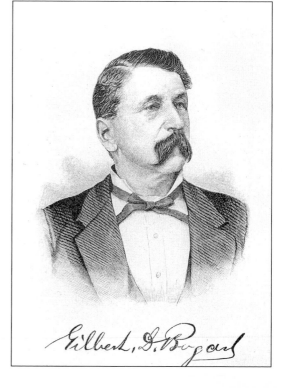

This *c.* 1880 engraving of Bogart was done at a time when the resilient and determined man had obtained enough financial backing to repurchase the East Passaic Land in order to fulfill his dream of developing Garfield as a suburb of Passaic. On the day following the inauguration of Pres. James A. Garfield, Bogart boasted, "Don't speak of East Passaic anymore, call it Garfield, after the man who will lead this great country to prosperity."

The Belmont section makes up most of the city's second ward and was the second oldest neighborhood to be established. Daniel Van Winkle, who purchased the Hasbrouck (Octagon) house on Orchard Street along with 273 acres of land in 1877, named his new property Belmont (beautiful hill). Fire Company No. 2 and Public School No. 2 became known as the Belmont Fire Company and the Belmont School.

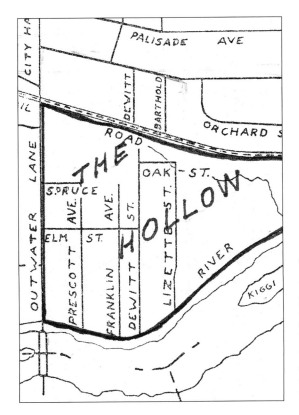

The Hollow section includes Franklin Avenue, Lizette Street, and Prescott Avenue. It is really a subsection of Robertsford (the next section to be described). The Hollow was so named because it has the lowest elevation in the city. This section has also been called Twin Bridges in reference to the two bridges constructed over Fleischer's Brook in 1927.

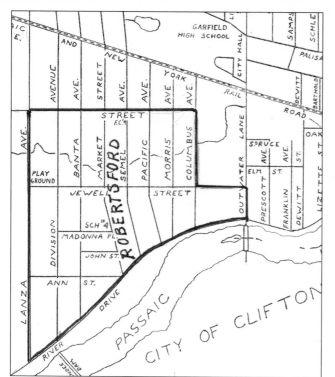

The Robertsford section was named after James Roberts, who in 1892 built a woolen mill on Outwater Lane near the river (later purchased by Samuel Hird). Roberts also erected the Philadelphia-style row houses on Jewell Street for his employees. Today, the section is part of the city's fourth ward and extends northward from Outwater Lane to the area of the Dundee Dam and eastward from the river to Palisade Avenue.

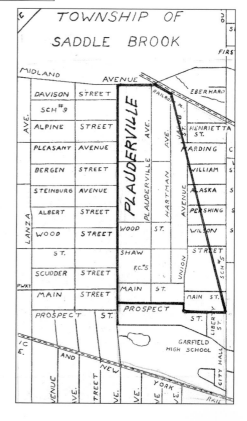

In the spring of 1896, a group of German immigrants from New York purchased the old Amos Brand farm and established the Plauderville section. Up until this time, the area had been called Bear's Nest. The new inhabitants built a small factory and soon established their own post office, railroad station, and fire company. Game warden Larry Stewart afforded early police protection in the neighborhood. The borough of Garfield annexed the Plauderville section on December 28, 1899.

Bogart Heights—or Garfield Heights, as it was later called—has the highest elevation in Garfield. This section, which makes up the city's third ward, was the last major land development to be promoted by Gilbert Bogart.

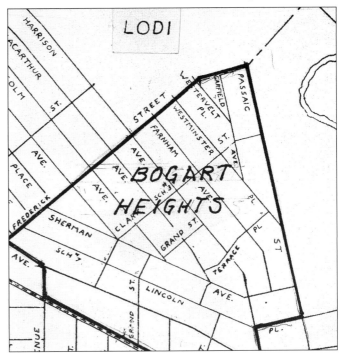

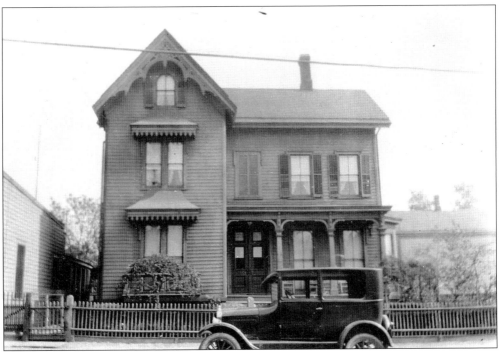

Shown in this late-19th-century photograph is one of the earliest houses still standing on Passaic Street. The two-story, wood-frame building was built in 1883, when Garfield was still a village within Saddle River Township. It was occupied for many years by Garret Henry Dulmer, a dyer in the textile industry. Dulmer was born in Prussia in 1858 and immigrated to the United States c. 1880. James U. Lemon, a member of the borough's first council, later occupied the house.

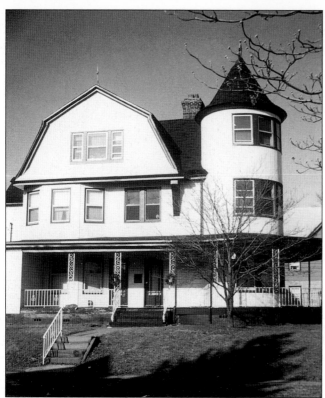

Located on Hobart Place is one of the relatively few houses in Garfield that displays a corner tower, a popular feature in early-20th-century domestic architecture.

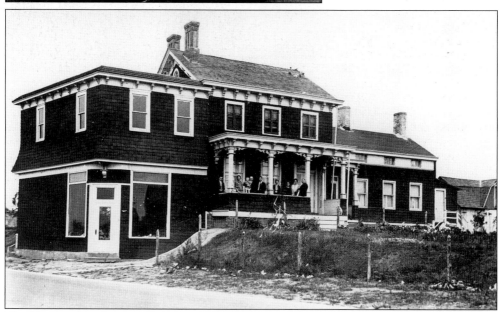

The Kopacka home was built by George Kopacka Sr., who had purchased the land from John Banta, whose house had burned on November 12, 1911. Posing on the porch of the new home at 800 River Drive in this *c.* 1920 photograph are, from left to right, George Kopacka Sr., Mary Kopacka, John Servas Jr., John Servas Sr., Emil Kopacka, Geza Kopacka, Rose Servas, Catherine Kopacka, and George Kopacka Jr.

14

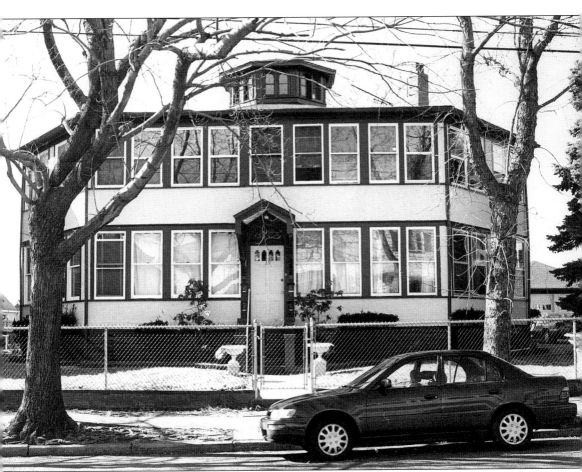

The eight-sided Octagon House is located at 23 Orchard Street in the Belmont section. Although thought by many to be unique, there are hundreds of similar houses still in existence—mostly in New York State. Built in the 1850s, it is the only early building in the city that retains sufficient architectural integrity to be an important remnant of the area's agricultural phase of development. It was built for Augustus Hasbrouck (1809–1881), who came to Garfield from Goshen, New York, to raise produce for the New York City market. Prior to 1867, he had sold the house and 93-acre farm to Daniel Van Winkle, who renamed the estate Belmont. Van Winkle continued to acquire adjacent properties until his estate totaled 273 acres in 1876. When he died in 1886, his heirs subdivided the farm and sold it as building lots.

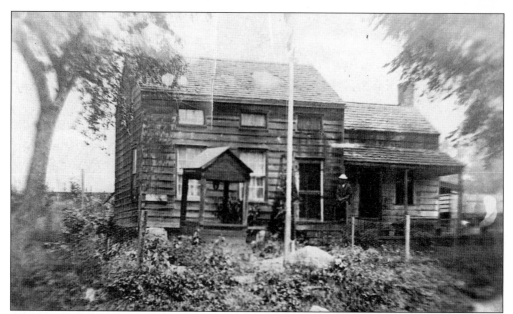

The Bush residence, shown in this *c.* 1900 photograph, once stood on River Drive near Bogart Avenue and was one of the earliest houses built in the Peck Hook section. The *Garfield-Belmont Directory* of 1903 lists residents Garret William and Peter R. Bush as being mill hands. A well and what appears to be a large flagpole dominate the front yard. The ghostlike figure seen at the right of the photograph is the result of a double exposure. (Courtesy John Buono.)

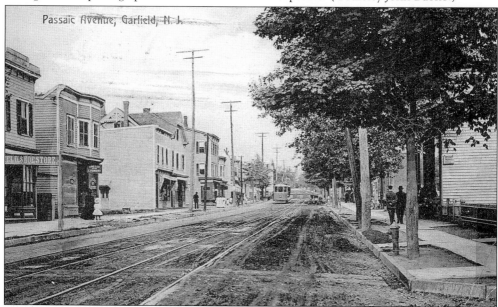

Numerous businesses line an unpaved Main Street in this *c.* 1910 photograph taken looking east along Passaic Street from Washington Place. Sing Lee Laundry (the second store on the left) and Kornhoff's (a large bakery a little farther down the street at the corner of Palisade Avenue) were among the earliest establishments here. The rented fire hydrants, curbing, bluestone sidewalks, and the electric poles were installed a few years before this photograph was taken. The trolley in the distance carried passengers to Lodi and Hackensack.

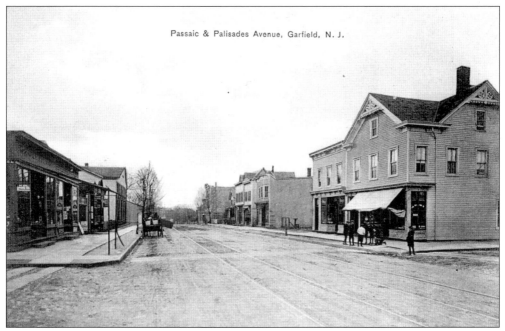

Kornhoff's bakery is at the northwest corner of this pre-1897 photograph taken looking west along Passaic Street from the intersection of Palisade Avenue. Next door to Kornhoff is Lee Sing's laundry; on the opposite corner is a grocery store. Although the trolley tracks are seen running down the center of the street, the electric poles for the trolley had not yet been installed.

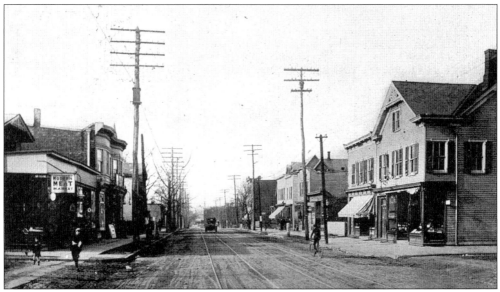

This later view of the intersection of Passaic Street and Palisade Avenue shows a single car traveling east along unpaved Passaic Street. The borough frequently applied a mixture of used motor oil and tar over the surface of the road in order to minimize the dust kicked up by passing cars. The first building at the left is that of the Modern Meat Market.

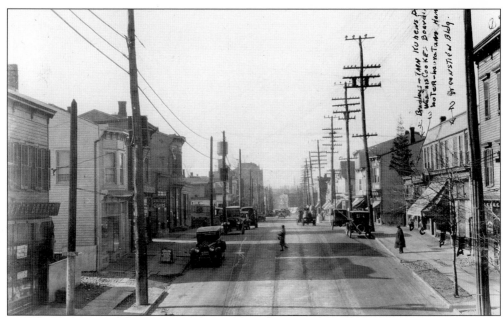

By the 1920s, cars, trucks, and buses were well established as the preferred means of transportation. This scene, looking west along Passaic Street, shows the busy business section of Garfield during the Roaring Twenties. At the right is the building owned by Max Greenstein, who operated a tailor shop on the first floor. (It is the first building with the awning.) When School No. 1 and School No. 2 became overcrowded, temporary classes were set up in the Greenstein building. Next is Mrs. Cooke's boardinghouse, followed by Bradley's Pharmacy (later Kuhnen's drugstore).

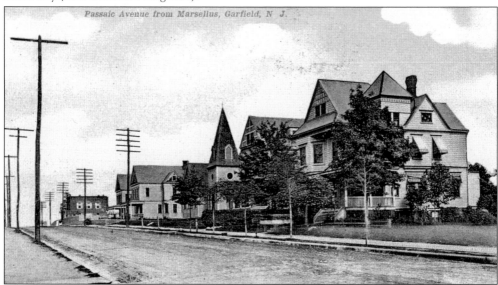

This postcard photograph, looking east along Passaic Street from Marsellus Place, was taken in the late 1890s. The steeple at the center is that of the First Reformed Church. The large building near the corner was a hotel and restaurant. Note that the electric poles are present but that the construction of the trolley tracks had been halted when a few residents would not grant permission to allow the trolley to pass in front of their properties.

Two

EDUCATION
AND WORSHIP

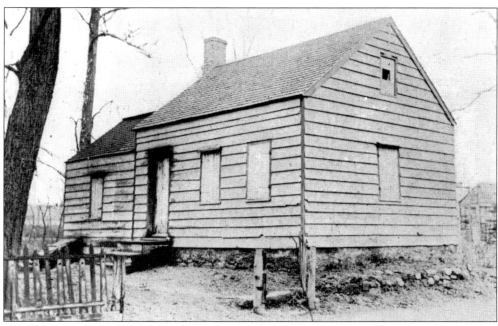

The first school in Garfield was established in the early 1800s by Saddle River Township in school district 42, at Slaughterdam, as it was then called. The schoolhouse was first located on River Drive near Belmont Avenue but was later moved north to a location near Lizette Street. The township charged the parents a school fee in 1849 of $1.75 for a quarter term, plus 6$1/2$¢ for a reading book. The school year was continuous. However, during spring planting and early harvest periods, the boys were allowed to stay home and help with farming chores. Although no photograph of the Slaughterdam School is known to exist, it was similar to the one shown here. This school was erected in 1833 for school district 35 (now in Lodi).

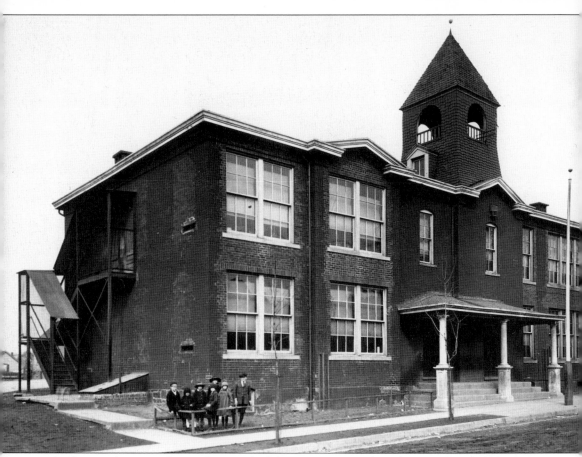

As the population in the southern end of the town increased to about 1,300 in 1880, a two-room, two-story brick building (complete with a bell tower) was erected on Commerce Street in the fall of 1882. Land for the building was secured from Gilbert Bogart, and one year later, the first free public school in Garfield was ready for occupancy. Joel Horton was the teacher, principal, and janitor. He swept the floor, chopped firewood, carried coal up from the cellar, and made the fire. Children were assigned the task of fetching water. Attendance at the new school grew so rapidly during the first year that an assistant, Lizzie Brevoort of Lodi, was hired to take charge of the primary department. Ellsworth Shafto became school principal in the fall of 1887. The First Presbyterian Church held Sunday services in an upper room of the school until its church was built in 1894. The building also served as the town meeting hall until 1905.

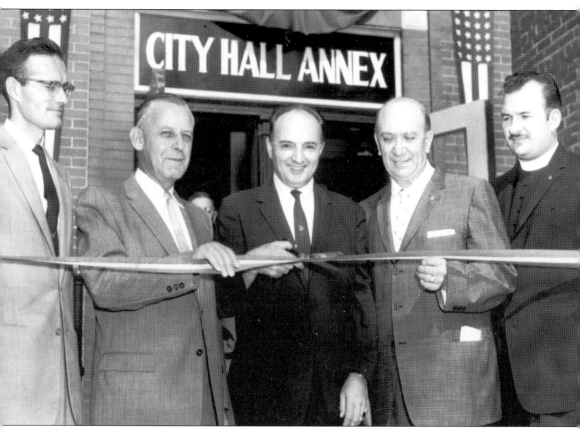

This photograph shows Mayor Joseph Kobylarz cutting the ceremonial ribbon on October 10, 1959, when the building of School No. 1 was dedicated as the City Hall Annex. Offices were set up for the Welfare Commission, Weights and Measures, Electrical and Building Inspection, Police Reserves, and the Recreation Commission. Rev. Ralph Bohn (far right) attended because the First Presbyterian Church held services in an upper room of the school until its building was constructed.

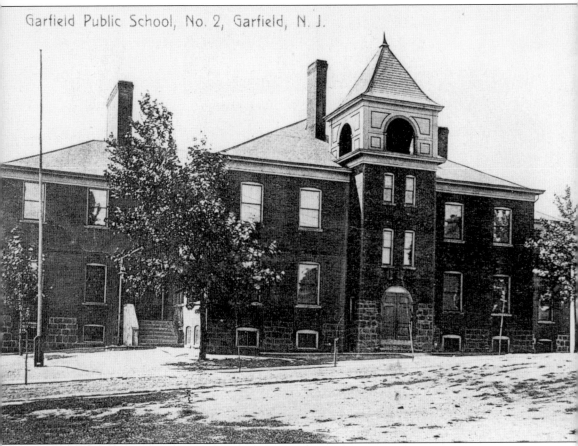

By 1898, classrooms again became crowded and voters authorized the Saddle River Board of Education to purchase a piece of land from the A.W. Van Winkle Real Estate Company of Rutherford for $300. The four-room building was erected on Palisade Avenue near Botany Street. The building shown in this photograph includes two additions that were constructed just four years later at a cost of $22,000. Each of the additions had four classrooms. Once completed, all primary grades were consolidated into School No. 2, but there were still 87 more children waiting to enroll. Garfield school principal Ellsworth Shafto and Dr. Nicholas Murray Butler, who was president of the New Jersey Board of Education at the time, next set up a training program in the school's basement. A. Albert Link was hired as an instructor. In 1907, Link's class was awarded a silver medal at the Jamestown Exposition for its exhibit of furniture built at the school.

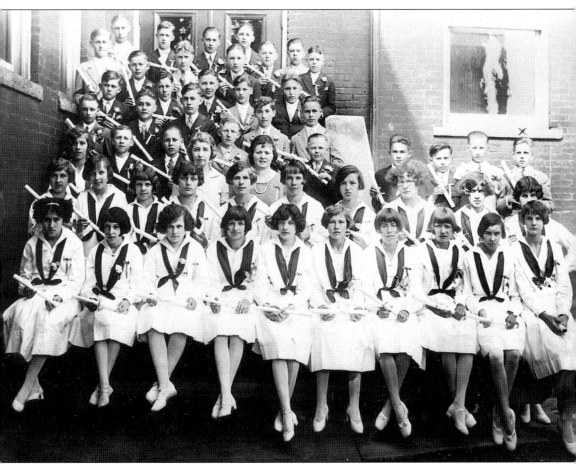

Graduating students in this 1926 class photograph taken at School No. 2 include, from left to right, the following: (first row) Esther Schatsman, Lena Ackerman, Anna Meltzer, Tessie, three unidentified students, Anna Domboski, Edna Leissner, and Frances Hartmann; (second row) Sophie Sukowroski, Elsie Yonko, Elizabeth Yuhas, Charlotte Majdanski, Eleanor Gregor, Elizabeth Toth, one unidentified student, Caroline Holzer, one unidentified student, and Mary Belli; (third row) one unidentified student, Joe Lovas, Gene Renel, Andrew "Red" Simko, Mike Smalz, Harold Huebner, Anthony Fornalik, one unidentified student, and Harold Pruefer; (fourth row) Ed Bombel, Steve Wurst, Knoedl, one unidentified student, and Eugene Steidel; (fifth row) Peter Sperl, Paul White, one unidentified student, Andrew Sabonash, and one unidentified student; (sixth row) John Hennecy, Ed Lehner, ? Bodie, ? Socka, Alex ?, and John Kmetz; (seventh row) John Dudas, Red Moses, Paul Pierce, Steve Szuros, and Harold Kristof. At the center are teachers Morris and Griffith. (Courtesy Harold Pruefer.)

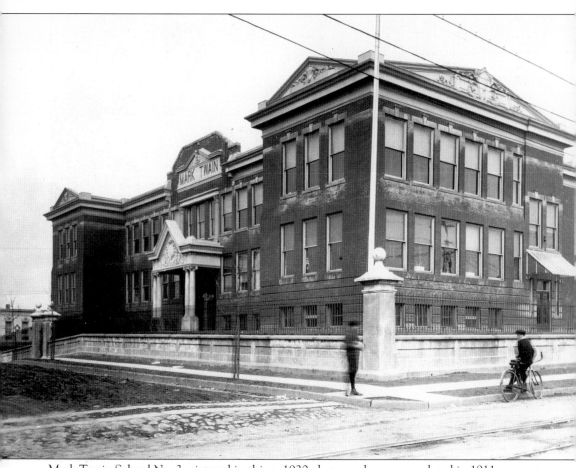

Mark Twain School No. 3, pictured in this *c.* 1920 photograph, was completed in 1911 at a cost of $48,000. When it was decided to name the school after Mark Twain, the board of education wrote to Twain's daughter, requesting permission to use the name. She was delighted with the idea and offered to donate a portrait of her late father to the school. The presentation of an American flag by the Order of Foresters highlighted the formal opening of the school on February 25, 1911. Because the school was built on a high hill, it was believed that all classrooms, including the basement rooms, would receive perfect lighting. Garfield was expanding at such a rate in those days that this school was immediately filled; it was then necessary to continue use of the lunchroom at the Garfield Worsted Mill as classroom space. Two additional classrooms were set up in the Plauderville Avenue firehouse (Fire Company No. 5).

Vesta Smith, a teacher and principal in the Garfield school system for more than 40 years, stands alongside her first-grade pupil Peter Nicastro at School No. 3, where she began teaching in 1928. Peter went on to become one of the most prolific and widely known photographers in the area. Many students recall having their high school graduation portraits taken at Nicastro's Studio on Harrison Avenue. (Courtesy Vesta Smith.)

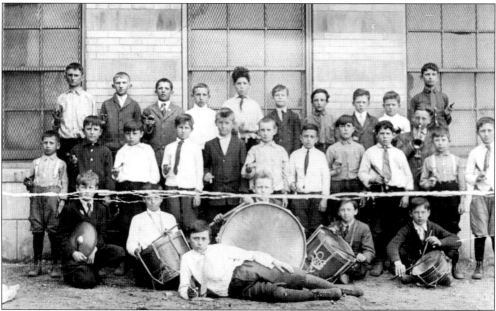

This 1920s photograph is the only one known of the Fife and Drum Squad of School No. 4. Marching bands, playing patriotic tunes, were very popular around the time of World War I. The knickers worn by most of the students in this photograph were the style of the day for boys. (Courtesy Charles Rabolli.)

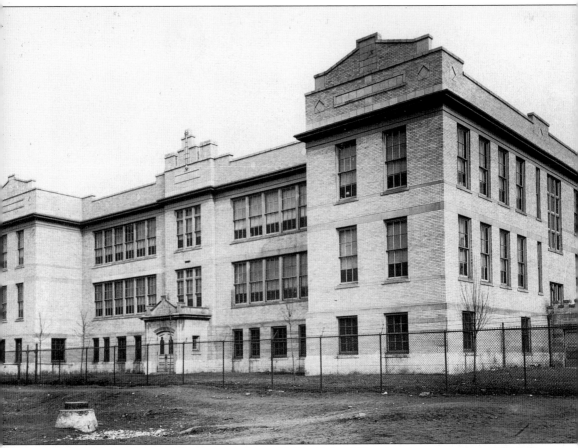

This photograph shows Washington Irving Public School No. 4 as it appeared in 1920. The building was completed on April 1, 1914, at a cost of $68,000 (including the cost of the land). It was immediately filled with students, while the first three schools remained crowded. Early in the morning of December 16, 1915, School No. 4, the newest and best school in Garfield, was nearly destroyed by fire. Fortunately, the fire had broken out at a time when the building was unoccupied. However, this event once again made it necessary to open annexes and to place several more classes on part time. Three classes were placed in the Plauderville firehouse, and six were sent to St. Stanislaus Kostka School. The extensive damage caused by the fire took a little over two years to repair. School No. 4 was once again ready for occupancy on February 1, 1917.

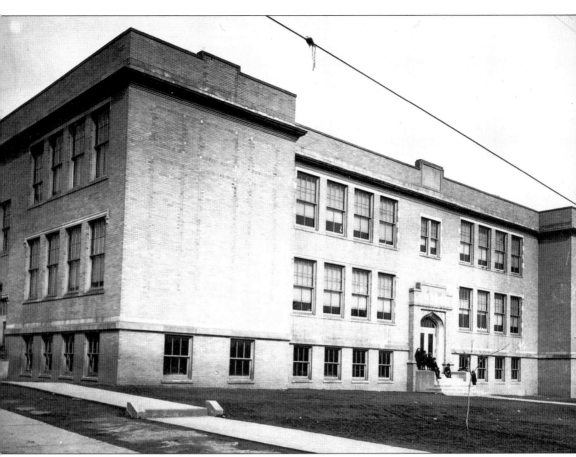

By 1918, there were more than 4,300 pupils attending public schools in Garfield, with approximately one quarter of them enrolled in School No. 3. Woodrow Wilson Elementary Public School No. 5, the first school in the Plauderville section, was built on land that was originally owned by Joost Cogh, a homesteader, who had purchased property on Toer's Lane (now Outwater Lane) in the 1700s. School No. 5 opened in May 1918 and was immediately filled with more than 500 pupils, most of whom were from the Plauderville section. In 1952, a public skating rink was added behind the school. Although it was primarily designed for roller-skating, the recreation department would flood the rink in winter, and ice-skating would be encouraged without the risks associated with pond or river ice-skating. Opening night featured an exhibition of artistic and precision roller-skaters from New York and New Jersey. The Emergency Squad of Fire Company No. 3 provided the lights for the nighttime exhibition.

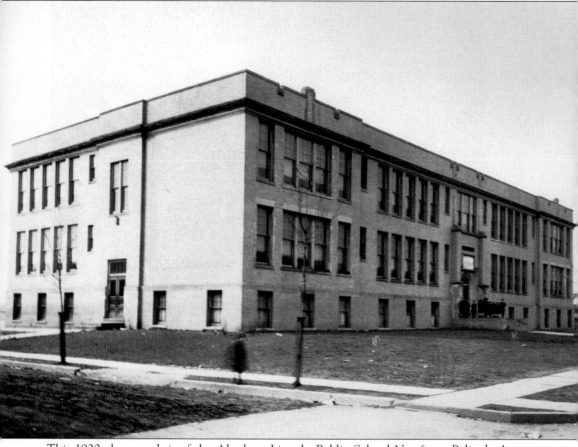

This 1920 photograph is of the Abraham Lincoln Public School No. 6, on Palisade Avenue near Passaic Street, which was completed in September 1918. The school had an enrollment of nearly 600 pupils. Curtains for the school's auditorium stage were paid for with pennies collected by Girl Scouts of the Mountain Laurel Troop of Garfield. Although primarily a grade school, it also served as the city's first high school. The high school marching and concert bands were developed in the large music room in the basement. Before the building was used as a high school, Garfield students attended Passaic, Hackensack, or Hasbrouck Heights High Schools. The first Garfield High School graduation ceremony was held in June 1923 with a class of about 15 students. Together, School No. 5 and School No. 6 added 28 classrooms, but the steady increase in population soon exceeded the capacity of all the schools.

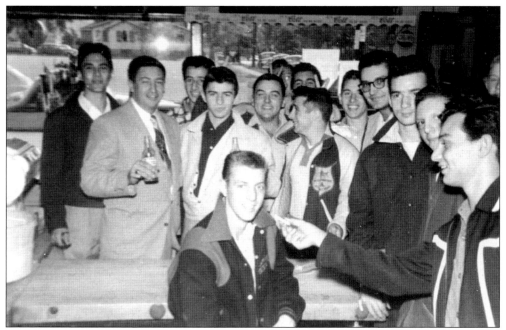

This 1954 photograph shows a group of School No. 6 students watching television in Stephen Ferenc's store at 43 Hudson Street. From left to right are Matt Garippa, coach Lee Wolsky, Sammy Broncato, Bratch Guerrieri, Jo-Jo Barcelona (seated), Carl Conoscenti, an unidentified student (partially visible behind Conoscenti), Buzzy Cataliato, an unidentified student (behind Cataliato), an unidentified student, Walt Jagiello, Ray Gretchen, Anthony Santora, Jack Adragna (offering cigarette to Barcelona), and an unidentified student. (Courtesy Mike Ferenc.)

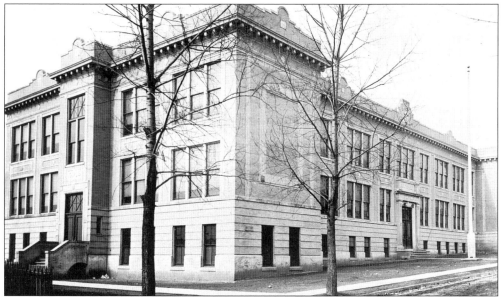

The next public school to be built in Garfield was the one shown in this 1920s photograph. Theodore Roosevelt Public School No. 7 was built in 1921 at Lincoln Place in order to provide classrooms for the children of the city's third ward. Upon the opening of this school, Garfield became the largest school system in Bergen County.

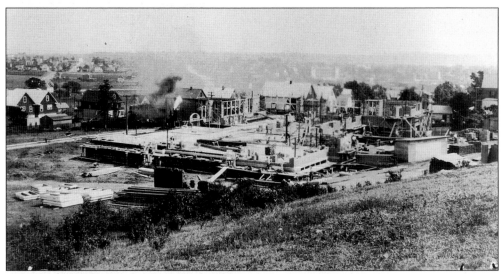

The start of construction of Public School No. 8 is shown in this 1926 photograph taken from Belmont Hill looking southeast. In the background can be seen the large steam shovel, parked on Cedar Street and used in various stages of the construction. (Courtesy Garfield Historical Society.)

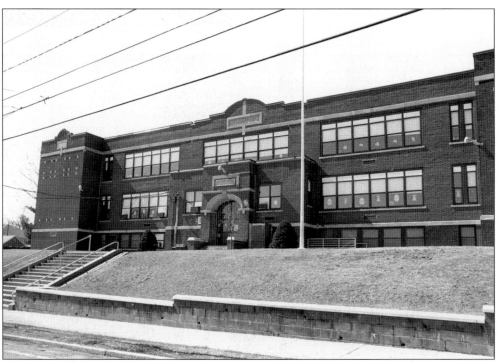

The school, looking virtually the same as it appears in this 1997 photograph, was opened as a school for kindergarten through eighth grade in 1926. In the 1950s, pupils from the overcrowded School No. 5 were sent to the larger No. 8, where they completed grades seven and eight.

Teacher Vesta Smith snapped this 1937 photograph of some of her students forming a pyramid on the school grounds at No. 8. From left to right are the following: (bottom row) George Handzo, Charles Kurak, Joseph Reiss, and Andrew Sature; (middle) Walter Mielnik and Warren Leonard; (top row) Edward Kohnowich. (Courtesy Vesta Smith.)

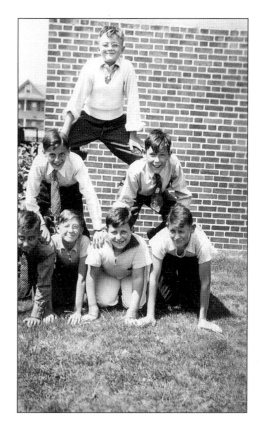

These fifth-grade students posing on the entrance steps of School No. 9 in this 1938 photograph have just participated in a school play. Some proud parent possibly took this photograph but accidentally excluded the faces of four of the children standing in the back row.

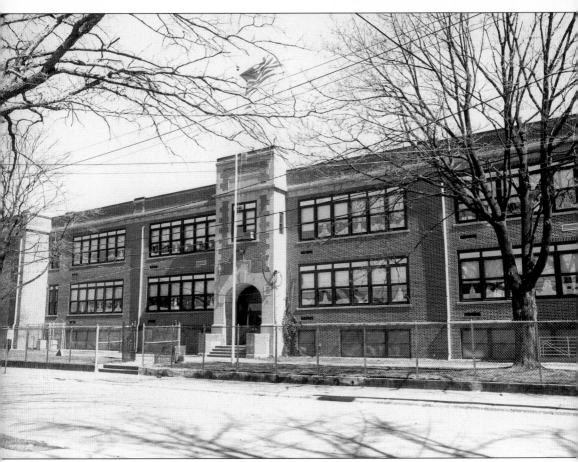

Public school enrollment by 1927 had reached nearly 7,000 and was still growing when a ninth school was proposed in 1926. However, the cornerstone for Thomas Jefferson Public School No. 9 on Alpine Street was not placed until 1929. The years of the Great Depression further delayed its opening until c. 1937. Garfield's newest and most modern school had a combination auditorium and gym and offered training classes in woodworking and domestics such as sewing, cooking, and baking. Although originally intended as a grammar school, the dramatic increase in the number of students attending high school following the end of World War II required that it be used exclusively as a first- and second-year high school. Junior and senior classes were sent to School No. 6 until 1956, when the new high school was built. When this photograph was taken in 1997, Thomas Jefferson School No. 9 was being used as a middle school.

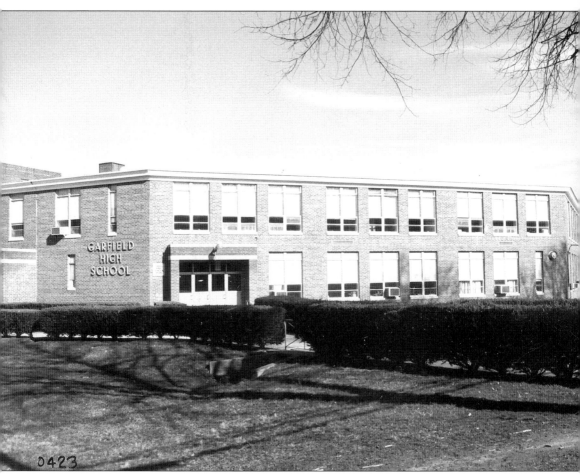

0423

In 1923, a high school was established in School No. 6; the first class to graduate that year consisted of about 15 students. Before this time, pupils had to commute to the high schools in Passaic, Hackensack, or Hasbrouck Heights. However, as more and more students went on to higher education, School No. 6 was not large enough to serve as a secondary school for the entire city. Eventually, space permitted only junior and senior classes to attend here. This photograph shows the main entrance of Garfield High School. The long awaited secondary school was built at the corner of Outwater Lane and Palisade Avenue. Cornerstone ceremonies were held on January 28, 1956, and classrooms were ready that September. It was the very first school in Garfield to be designed exclusively as a secondary education facility and was a landmark achievement in the development of the city's educational system.

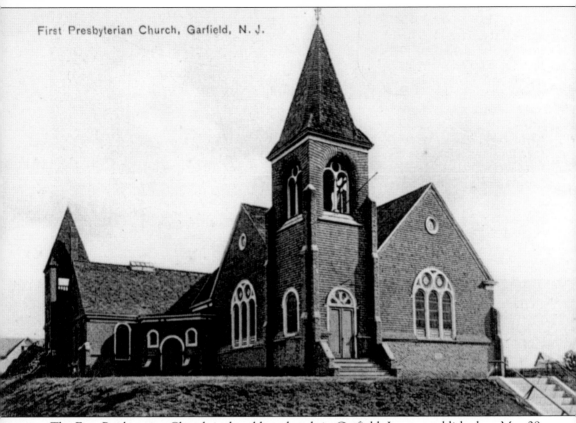

The First Presbyterian Church is the oldest church in Garfield. It was established on May 29, 1888, with 14 charter members. In June, William B. Hepworth, one of the first mayors of Garfield, persuaded several other prominent citizens to join him in acquiring and then donating the land and building at the corner of Palisade Avenue and Commerce Street to the new congregation. Work to convert the existing building into one suitable for church services was completed in the fall of 1889. Rev. James Hall was called as the first minister, and the first religious services were held in the church on November 3, 1889. On July 2, 1904, the cornerstone was set for a second building (seen here), and on October 19, 1934, a third building program funded Fellowship Hall. In 1939, the First Presbyterian Church merged with the Garfield Italian Presbyterian Church. The fourth and present building was dedicated on October 30, 1960.

In 1889, the citizens of Garfield donated this bronze bell to the First Presbyterian Church. As the bell's inscription states, the bell was "to be used by the church and in case of fire or alarm." While the use of this bell was a convenience, it also caused firemen considerable trouble. Local boys would fasten a rope to the bell and then ring it and run. Finding no fire, the men had to draw their apparatus back to headquarters.

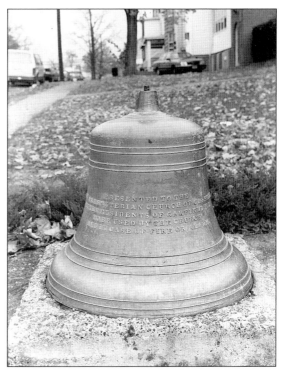

The First Reformed Church was located on Passaic Street near Marsellus Place and was founded in 1891 by the First Reformed and North Reformed Churches of Passaic. Mr. and Mrs. Henry Marsellus donated a portion of their land, and two Passaic congregations lent the money needed to erect the church and parsonage. Rev. George Seibert was called as first pastor in October 1891. The church and parsonage buildings (pictured) were dedicated on February 21, 1904.

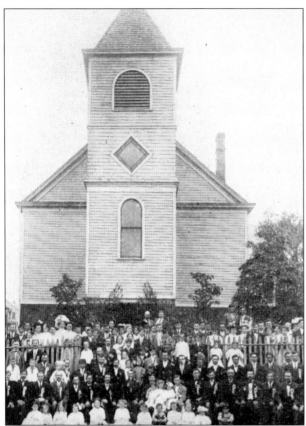

The Russian Orthodox Greek Catholic Church of the Three Saints was started by a group of families who emigrated from Carpathian Mountain regions of western Russia in the late 1880s. Wanting to have a congregation of their own, they organized in March 1898 and erected this wood-frame building in 1901 at the corner of Cambridge Avenue and Commerce Street. When, on August 18, 1915, a wind-swept fire destroyed the building, the parishioners immediately set out to erect a new brick building at this site.

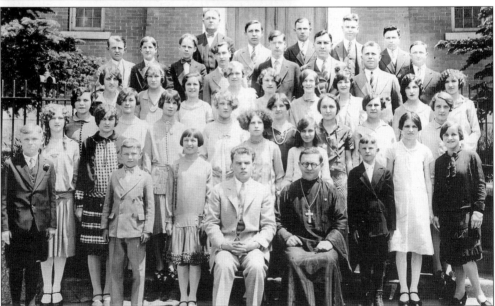

This c. 1930 photograph shows members of the choir of the Russian Orthodox Greek Catholic Church of the Three Saints gathered in their Sunday best at the church's second building, erected in 1915 at the corner of Cambridge Avenue and Commerce Street. (Courtesy Michael Ferenc.)

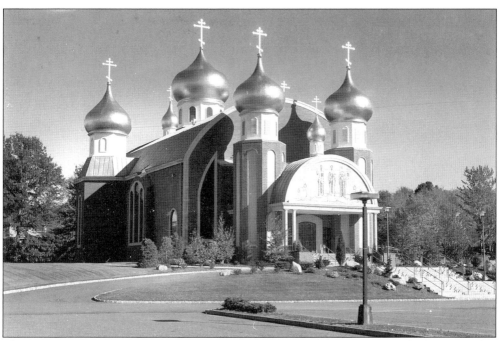

The Russian Orthodox Greek Catholic Church of the Three Saints purchased a large parcel of land on Outwater Lane, near McDonald Street, in the late 1960s from William Srob, who ran a dairy farm there for many years. Construction of this third and present church began in 1982 and was completed in 1984. (Courtesy Michael Ferenc.)

The congregation of the Holy Trinity Evangelical Lutheran Church was organized on August 10, 1892. The founders, who were Slovak immigrants, held their first church services in the basement of the First Presbyterian Church in Garfield. On April 20, 1902, a wood-frame building was erected on Palisade Avenue. In 1926, the church building was physically moved to Summit Avenue for use as a Christian day school, and the present gothic brick structure, seen in this photograph, was built on the original site.

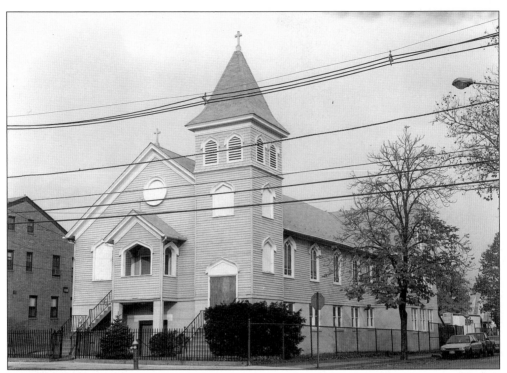

St. Stanislaus Kostka Roman Catholic Church was founded in 1900 by a group of Polish immigrants who settled in Garfield. From 1908 to 1914, masses were held in the firehouse of Company No. 5 on Plauderville Avenue. In June 1914, the wood-frame church (seen here), which included four school classrooms, was erected at the corner of Ray Street and Division Avenue. The present brick church and school were built at the corner of Ray Street and Lanza Avenue and dedicated on June 30, 1929.

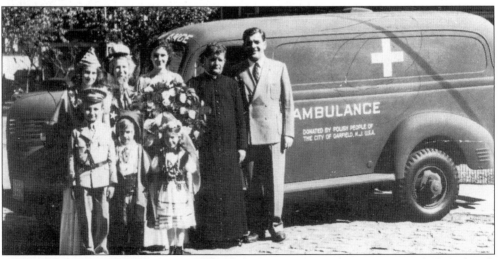

During World War II, the parishioners of St. Stanislaus Kostka Roman Catholic Church showed their support for the Polish people when they collected $1,000 to purchase an ambulance to be given to the Polish army. Rev. John F. Wetula is seen standing with parishioners of at the dedication ceremony held on May 10, 1943.

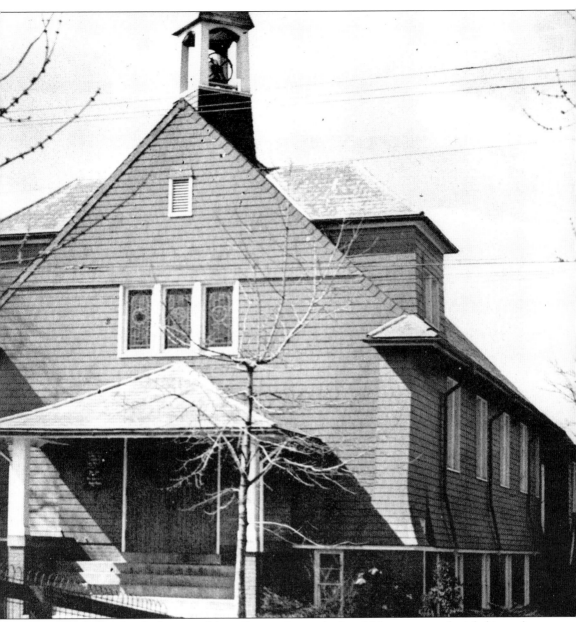

Many Catholics that had migrated from Europe during the late 19th century and settled in and around Garfield were still without benefit of local churches or priests. Subsequently, the Franciscan Order of Missionaries in Rome began a movement to establish mission churches in areas where Catholic services had seldom been offered. In 1911, Rev. Francis Koch, a Franciscan missionary, noted that a large number of parishioners attending St. Nicholas in Passaic actually resided in Garfield. The energetic priest, almost 80 years of age, celebrated the first mass of the Catholic Church of the Most Holy Name at Somerset Hall on Somerset Street on July 9, 1911. A short time later, Koch left for new fields, and Fr. Dominc Sonnabend became the first official pastor of the parish. Aided by 43 parish families, plans were designed, land was purchased, and the first church (shown here) was erected at Marsellus Place near Passaic Street in 1912.

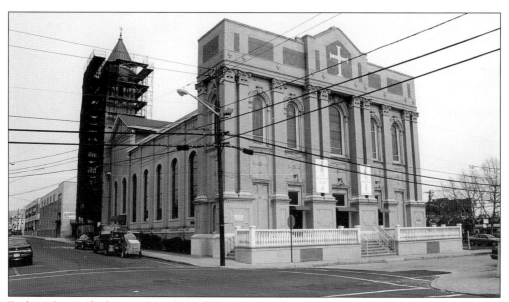

Feeling the need of a priest speaking their native language, a group of Italian Catholic families founded Mount Virgin Roman Catholic Church in 1901. The first religious services were held in Raphaele Fusco's butcher shop on Westminster Place. The church was incorporated in 1904, and a small chapel was built on Frederick Street. A new structure was erected at this site in 1907 to replace the temporary chapel. Shown in this photograph is the much larger, present church, built in 1927.

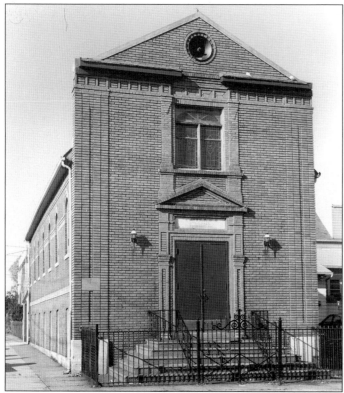

Our Lady of Sorrows Roman Catholic Church was started as a mission of Mount Virgin Roman Catholic Church in 1917 by a group of Italian immigrants who had settled in the Robertsford section of the fourth ward, where they found work in the textile mills. Seen in this photograph is the brick church building, built in 1918 at the corner of Jewell and Market Streets. The present building and school, located on Madonna Place, were dedicated on November 18, 1956.

This prayer card depicts the patron saint of Mussomeli, Sicily. In 1920, many immigrants from this town who were also members of Our Lady of Sorrows Roman Catholic Church became outraged when they were not permitted to honor the patron saint of their homeland. The group broke away and formed the Maria S.S. Dei Miracoli Italian Catholic Church and built a small, wood-frame building on Banta Avenue. However, by 1929, the congregation disbanded and most of its members returned to the Jewell Street church.

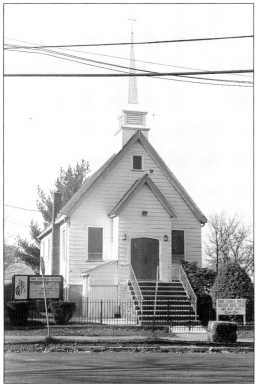

The Zion Lutheran Church was founded on February 9, 1919, in Kolbek's Hall, at the corner of Belmont and Wessington Avenues by some 30 Slovak families. One month later, it was officially organized as the Slovak Zion Evangelical Lutheran Church; its first services were held in the Presbyterian Church in Wallington. In 1923, the church purchased the building shown here. Located at the corner of Midland Avenue and Hepworth Place, the structure was originally built and occupied by the Holy Innocents Church.

41

The African American community of Garfield began worshiping together in the 1920s, meeting in homes and storefronts. On May 8, 1927, Mount Calvary Baptist Church was organized with Rev. Elisha L. Harrison as the first pastor. Among the first to enroll were members of the Logan, Buggs, Watson, Murray, Holston, and Butler families. Services were first held on Frederick Street. In 1929, the congregation moved to its present building on Harrison Avenue, and its name was changed to the Calvary Baptist Church. (Courtesy Calvary Baptist Church.)

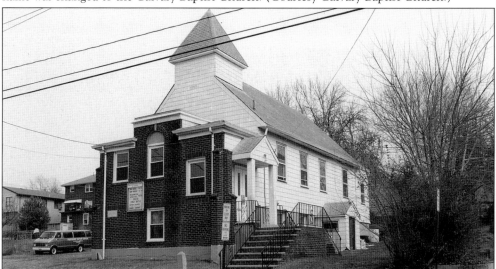

In 1941, a small group of members of Calvary Baptist Church decided to break away and organized the Friendship Baptist Church on February 21, 1942. Rev. James H. Penn was one of the first pastors. Officers included Henry Abney, John Logan Sr., Ella Logan, Mildred Randolph, Minnie Abner, Eugene Holston, John Pierce Logan, and Albert Broadnax. The cornerstone of the Friendship Baptist Church building, on Gaston Avenue, was set in place in 1948. (Courtesy Friendship Baptist Church.)

Three
TRANSPORTATION

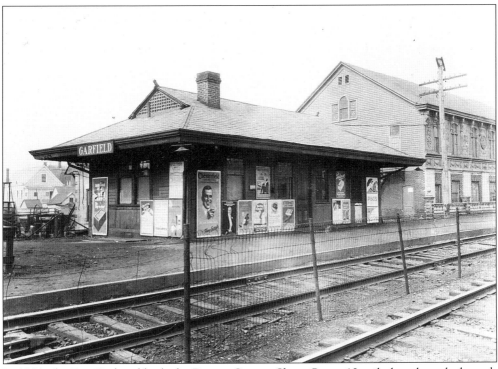

In 1881, the Erie Railroad built the Bergen County Short Cut, a 12-mile-long branch through Garfield. The passenger depot, shown in this *c.* 1920 photograph, was erected at the corner of Midland Avenue and Passaic Street and was named Garfield, in memory of President Garfield, who had been assassinated earlier in the year. James U. Lemon of Passaic Street, who had lost an arm in a railroad accident, was hired as one of the first conductors of the Short Cut line.

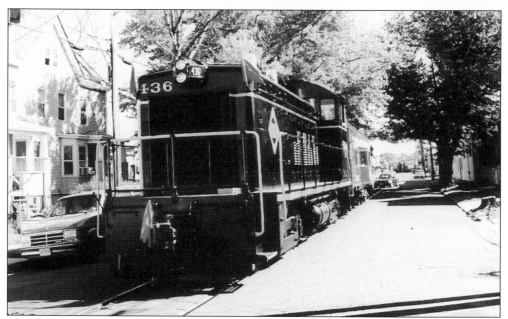

It is a common sight to see an Erie Railroad locomotive and caboose coming through the middle of town. Each year, scores of railroad buffs line a section of Monroe Street to witness and photograph the train making one of its trips to Passaic. What makes this event more unique is the fact that, by law, the train must stop at the two red lights at Palisade Avenue and at River Drive to give vehicles and pedestrians the right of way.

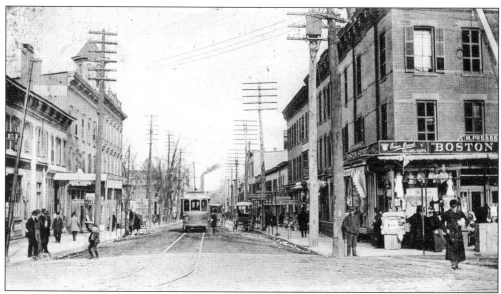

This *c.* 1904 photograph shows a trolley car heading to Garfield from Passaic. This line was the first electric railway in New Jersey and was put into operation in 1890. However, several obstacles delayed continuance of the line through Garfield—namely, a petition to cross the Garfield Bridge offered on grounds that the bridge was too weak. Eventually, this objection was overruled.

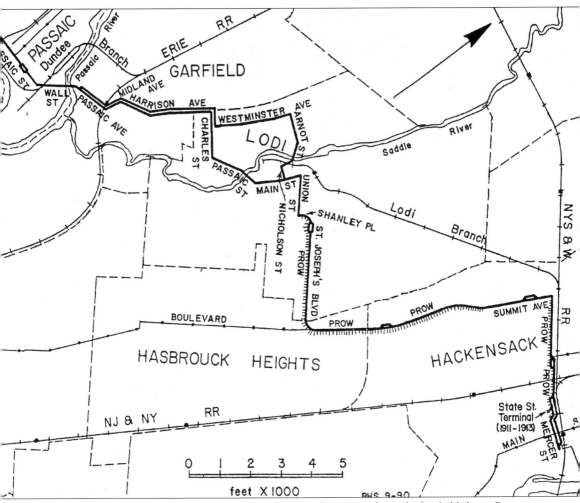

The trolley route that was originally proposed was to have run through Garfield down Passaic Street to Lodi. However, this map shows the seemingly bizarre route that resulted from actions taken by Henry Marsellus, a powerful foe of the pro-trolley Gilbert Bogart. "Boss Eel," as Marsellus was known, first spearheaded a drive to completely prevent the company from constructing a trolley road from the bridge. When this approach failed, he refused to grant his permission to allow the line to pass in front of his property on Passaic Street. Bogart was then forced to change the route in order to circumvent the Marsellus property. The new route began at the Monroe Street Bridge and continued east along Passaic Street to Midland Avenue, where the trolley turned left and proceeded to Harrison Avenue. Turning right on Harrison, the route proceeded to Charles Street, turned right to rejoin Passaic Street, and finally to Lodi and points beyond. (Map from *Public Service Railway, Bergen Division,* by B.H. Sennstrom and E.T. Francis; private publication by Harold E. Cox, 1994.)

45

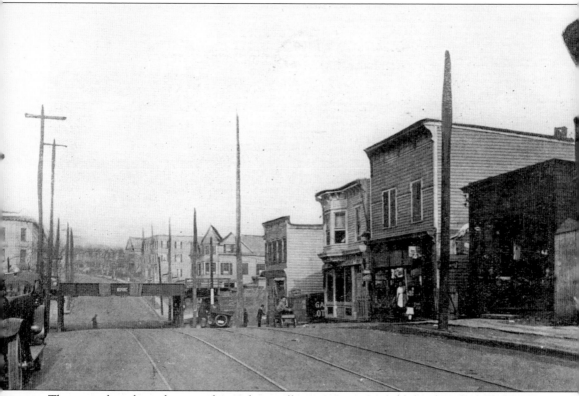

The next obstacle in the way of providing trolley service in Garfield developed when the Erie Railroad refused to allow a gate crossing at Passaic Street. They argued that since the tracks made a sharp curve at this point, the engineer would not have a clear view of Passaic Street. The Saddle River Traction Company then decided to lower the grade level of the street and run the tracks beneath the rails of the train. As can be seen in this c. 1920 eastward view of Passaic Street, the tracks lead to the under-grade and trestle. When completed in 1899, all seemed satisfactory, until the first rainstorm created a 200-foot-long lake in the hollow beneath the trestle. The company then installed drains and electric lighting and also lowered the grade another foot. Apparently, the original clearance did not allow for the actual height of the trolley car.

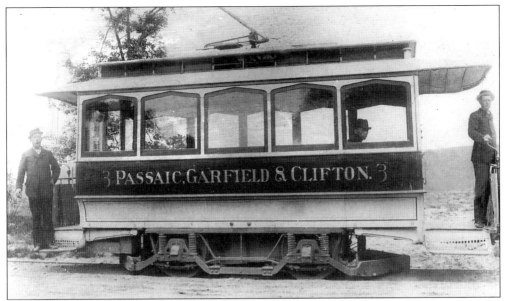

The Passaic, Garfield & Clifton electric trolley car No. 3 was built in 1890 and was one of the original electric cars used on the line. John N. Meade stands at the controls, and at the rear is Edward Hogan. This picture was taken on Main Avenue, between Summer Street and Burgess Place, at around the beginning of the 20th century, when there was not a house in sight. The last trolley run was made on this route in 1938. (Courtesy Frank B. Calandriello.)

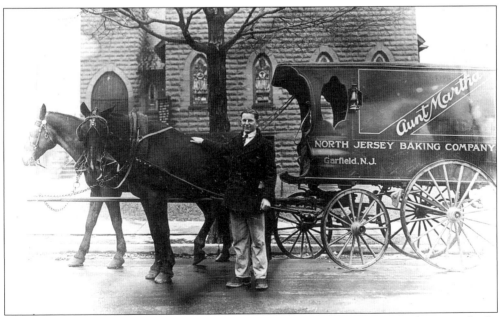

Before the dawn of motorized vehicles, a horse was used to pull just about anything on wheels. Those were the days when stagecoaches, trolley cars, passenger buggies, farm equipment, and peddler's wagons were all horse powered. This early-20th-century photograph shows the horse-drawn delivery wagon of the North Jersey Baking Company of Garfield, The company sold a line of bakery products under the name Aunt Martha. (Courtesy Dave Tylicke.)

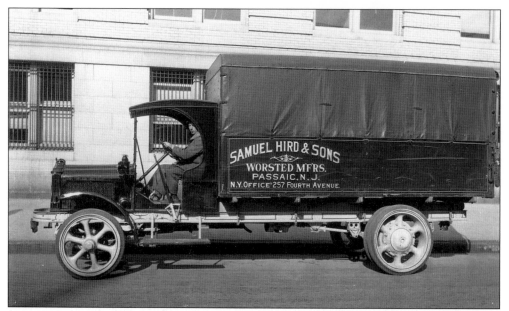

The delivery truck shown in this 1920s photograph is typical of the type used during the period. Although the lettering on the truck states that "Samuel Hird & Sons Worsted Mfrs." was located in Passaic, the mill was actually located in Garfield. When motor vehicle traffic increased during the 1930s, Samuel Hird donated 10 feet of his land to the city so that Outwater Lane could be widened in order to increase the flow of traffic at this busy intersection. (Courtesy Paterson Museum.)

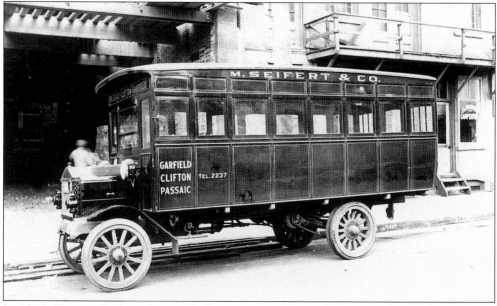

In 1915, Herman Seifert, along with his two sons, Max and Fritz, purchased the motorbus shown in this c. 1916 photograph. The M. Seifert & Company line of buses was sold during World War I to the newly formed Garfield Transit Company, a rival organization that was in turn purchased by the Garfield & Passaic Transit Company.

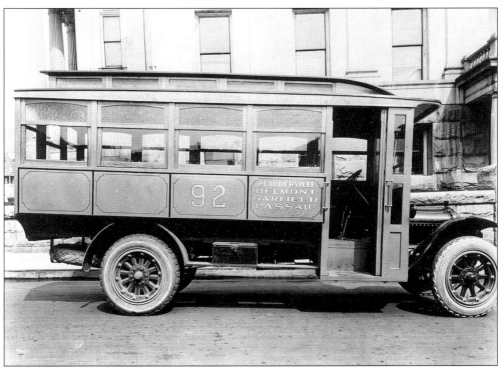

The bus in this 1917 photograph served Plauderville and Belmont. It was owned and operated by the Garfield & Passaic Transit Company, which had bought out the bus lines of M. Seifert & Company and the Garfield Transit Company. The new fleet of buses was housed in large garages that still stand at 157 Outwater Lane. The popularity of the bus over the trolley eventually led to the demise of the trolley system during the 1930s.

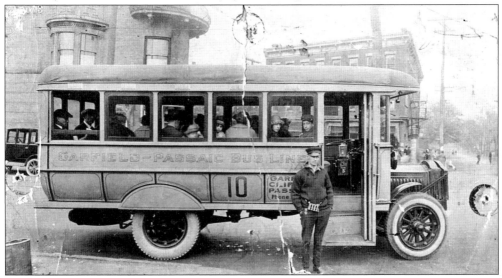

This unidentified uniformed driver (complete with coin dispenser on his belt) parked his bus in front of Higgie's Hotel in Passaic and posed for this c. 1920 photograph. Passengers aboard the No. 10 jitney of the Garfield–Passaic bus line appear undisturbed by this delay in reaching their destinations.

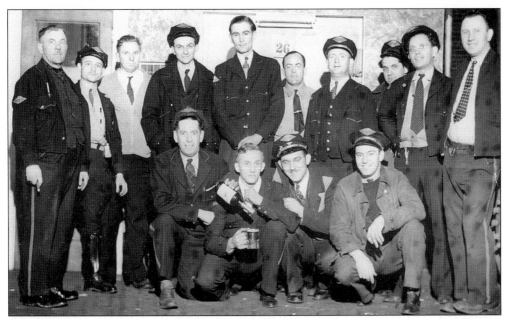

Arthur Kunkel of Little Falls snapped this late-1930s photograph of the crew of bus drivers employed by the Garfield-Passaic Transit Company as they enjoyed a happy lunch hour in the office of the bus garage on Outwater Lane. (Courtesy Helen Comment.)

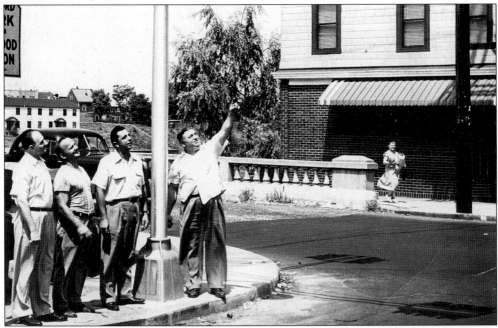

Police Chief Nicholas L. Perrapato points to the new-styled traffic lights operating at the intersection of River Drive and Monroe Street in 1953. Looking on, from left to right, are Joseph Kobylarz (councilman), George Stefanco (traffic superintendent), and Carmine Perrapato (councilman). Prior to this time, all traffic lights in town were of the simple pedestal type and not readily visible to approaching drivers until they reached the intersection. (Courtesy Sue Stefanco.)

Four

PROTECT AND SERVE

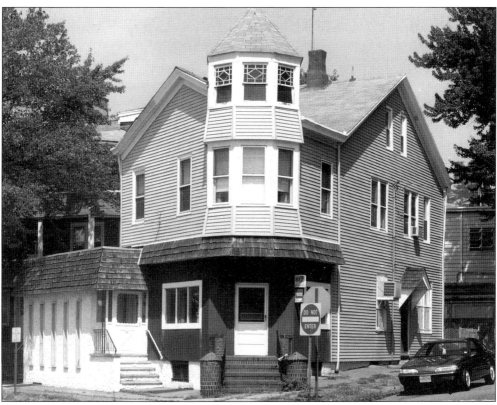

Frustrated by Saddle River Township's inability to provide fire protection for the village, a group of citizens met at Hollingshead Hall on July 7, 1893, to consider the formation of a fire company. The name originally selected for the company was Peck Hook Hose & Bucket Fire Company but was later changed to Garfield Volunteer Fire Company No. 1. This photograph shows the wood-frame building, formerly Hollingshead Hall, at the corner of River Drive and Washington Place.

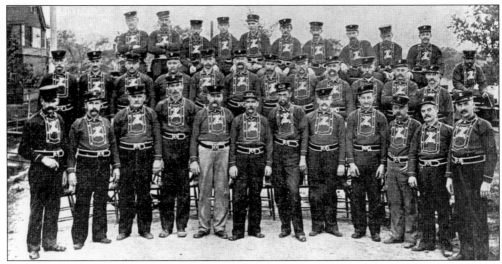

This *c.* 1894 photograph is the earliest known of the Garfield Fire Department. The company remained as an independent unit until March 13, 1896, when it was officially recognized by Saddle River Township. On July 23, 1898, the company came under the supervision of the borough of Garfield.

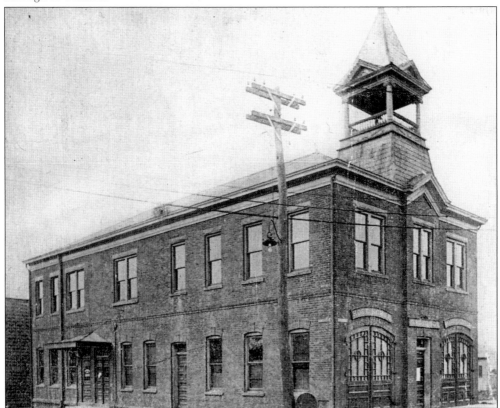

This *c.* 1908 photograph shows the firehouse of Fire Company No. 1, which was erected in 1900 at the corner of Somerset Street and Midland Avenue. In 1905, the building was sold to the borough and was shared with the police department. It also served as the borough hall.

Shown in 1905, the second firehouse of Fire Company No. 2 was built after the original building had burned down a year earlier. The original building had been moved a few feet down the road, but the company never had the insurance papers updated to reflect the address change. Therefore, they could not collect on their policy, and the $3,200 needed to construct the new building had to be raised by donations from company members and area citizens.

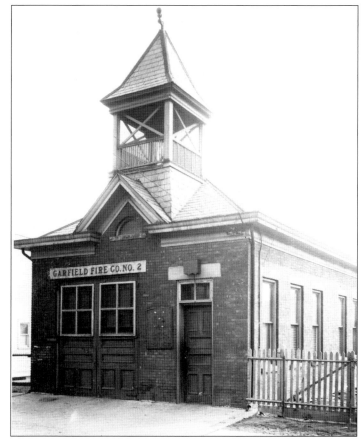

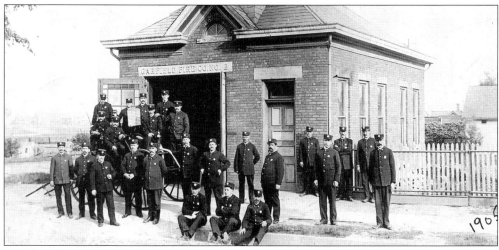

Members of Fire Company No. 2 pictured in this 1905 photograph are Richard Faber, Robert Dittrich, Wendel Roehrich, Paul Drada, Michael Bertha, Carl J. Jacob, Ernest B. Dahnert (later mayor of Garfield), Joseph Shamberger, Herman Tushinski, Max Walter, Otto Schiepan, Charles Janousek, Joseph Havelka, Max Klemm, John Svahra, Joseph F. Quinlivan, Jerry Catz, George W. Sabo Sr., Frank Horac, Joseph Buck, Theodore Winter, Frank Shamberger, Michael Estok, Joseph Jeckert, and Rudolph Shamberger.

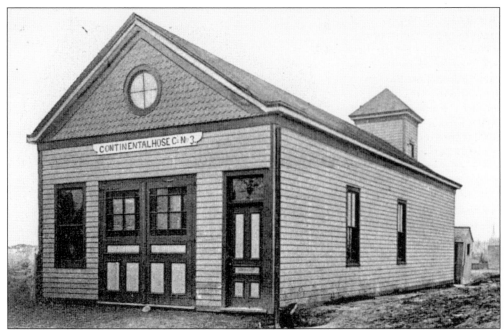

Fire Company No. 3 came about when a group of young men who hung around Company No. 1 were no longer permitted to take part in activities there. The rejected group organized the Continental Hose Company in December 1903. Shown *c.* 1905 is the original one-and-a-half-story wood-frame building on Palisade Avenue near Grand Street. It was not an uncommon site to see the members every evening digging the foundation for the building.

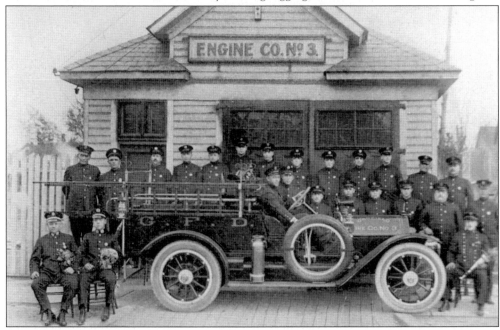

The members and the fire truck of Company No. 3 are shown in front of the second firehouse *c.* 1920. This building was constructed after the first building burned down. A third building was later built on Willard Street.

Garfield Fire Company No. 4 began in 1905 when a group of citizens from Plauderville and Robertsford wanted to establish fire protection in the northern part of the borough. However, arguments over the exact location of its headquarters resulted in two opposing factions. About a year later, citizens from the Hollow joined those from Robertsford and organized the Independent Fire Company. The fire apparatus, consisting of a hand-drawn hose reel, was stored in a rented barn on River Drive near Outwater Lane.

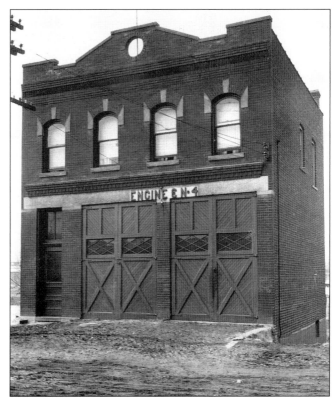

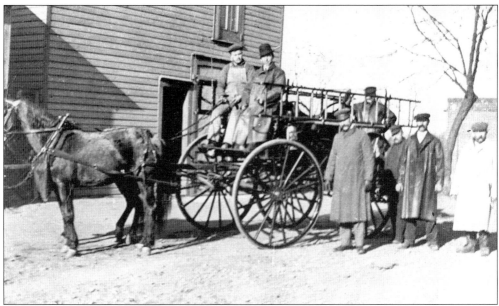

In 1908, Fire Company No. 4 received a small horse-drawn hose-and-ladder wagon to replace their hand-drawn hose reel. However, since the company did not have its own horses, firemen trying to get to a fire would have to flag down a passing teamster and borrow the horses, or pull the apparatus by hand. The members standing next to the wagon are, from left to right, Ben Servas, John Servas, August Eberhard, and J. Poltarik.

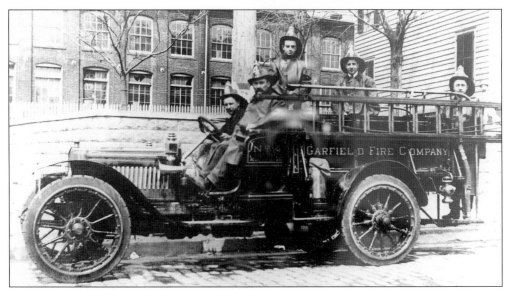

Members of Fire Company No. 4 proudly man the borough's first motor-driven firefighting machine *c.* 1915. Apparently, the company had become frustrated with its inability to respond quickly to fires and decided in 1914 to purchase a used Lozier automobile and have it converted into a fire truck. The borough imposed a maximum speed of 15 miles per hour when responding to a fire, but this rule was never enforced.

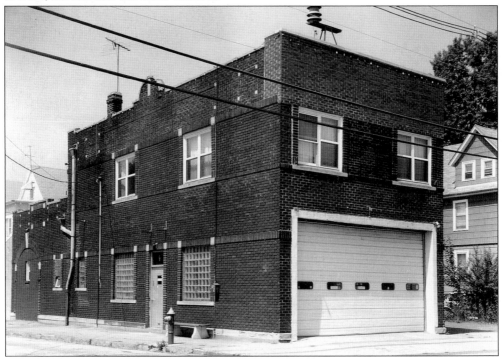

The 18-year-old Fire Company No. 4 finally obtained its own headquarters and engine house on September 9, 1923. This photograph shows the building, at the corner of Semel Avenue and Ray Street, which was occupied by the company from 1923 until the present building was constructed on Outwater Lane in 1994.

Garfield Fire Company No. 5, the last fire company to be formed in Garfield, was organized by a group of men from Plauderville who met in the Hartmann Embroidery Works factory at 68 Plauderville Avenue. Some of the charter members were from the group that had split off from Company No. 4. The company was incorporated on March 26, 1906, and two years later constructed their two-story brick building, seen in this photograph, at the corner of Plauderville Avenue and Shaw Street.

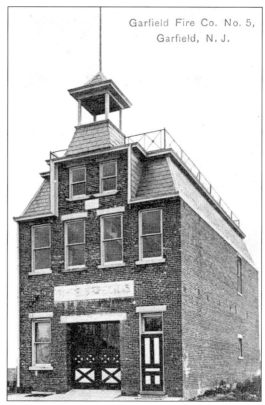

Garfield Fire Co. No. 5, Garfield, N. J.

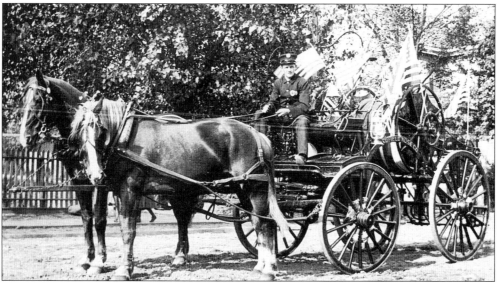

Shown c. 1910 is the horse-drawn hose reel of Fire Company No. 5. Strangely, the No. 5 firehouse was erected on land that neither the company nor the borough owned. In December 1919, the landlord sold the property, and the company had to move out. Dubbed "the Homeless Company," it was forced to house its horse-drawn apparatus under a shed on Wood Street until 1922, when the city erected a new firehouse on Plauderville Avenue between Main and Shaw Streets. (Courtesy Walter Nebiker Jr.)

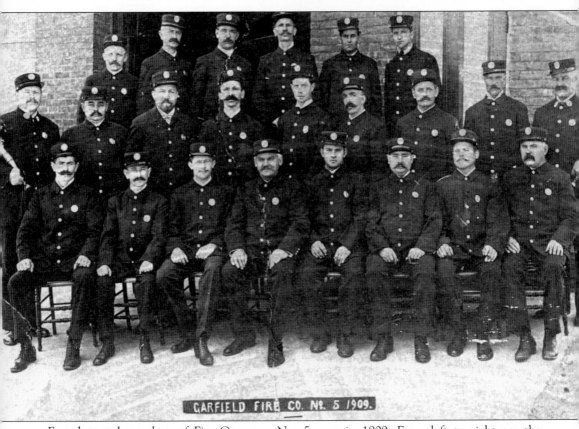

Founders and members of Fire Company No. 5 pose in 1909. From left to right are the following: (front row) A. Prais, L. Greenstein, W. Oberman, M. Mattauck, Joseph Hartmann Jr., P. Ohotsky, G. Koehler, and Joseph Hartmann Sr.; (middle row) W. Miller, J. Ohotsky, W. Herzog, A. Nebiker, C. Elgersma, W. Nebiker, J. Haas, G. Wagner, and H. Seifert; (back row) W. Mikalik, G. Schlegal, A. Beck, E. Nebiker Sr., G. Huebner, and E. Nebiker Jr.

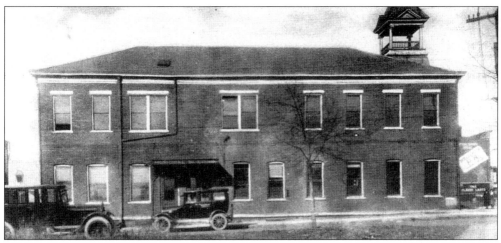

The Garfield Police Department was established on December 31, 1908. Police headquarters were set up in a portion of the borough hall and firehouse building shown in this c. 1920 photograph. The station had four cells, one of which was for women, and a pistol range in the basement. The borough next purchased a horse-drawn patrol wagon in 1911. The first police arrest was made on New Year's Day (1909) by Patrolman Bertha of a Passaic baker for selling his goods in Garfield without a license.

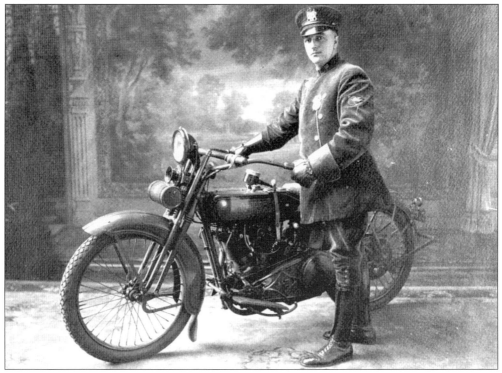

The police department of 1930 had grown to a force of nearly 40 members. There were 28 patrolmen, 5 detectives, and 3 that were assigned to the newly created motorcycle division. Werner Nebiker and his Harley Davidson motorcycle are seen in this late-1920s photograph. The Nebikers were one of the first families to settle in Plauderville. Nebiker's brother Walter ran a small store on Plauderville Avenue for many years. (Courtesy Walter Nebiker Jr.)

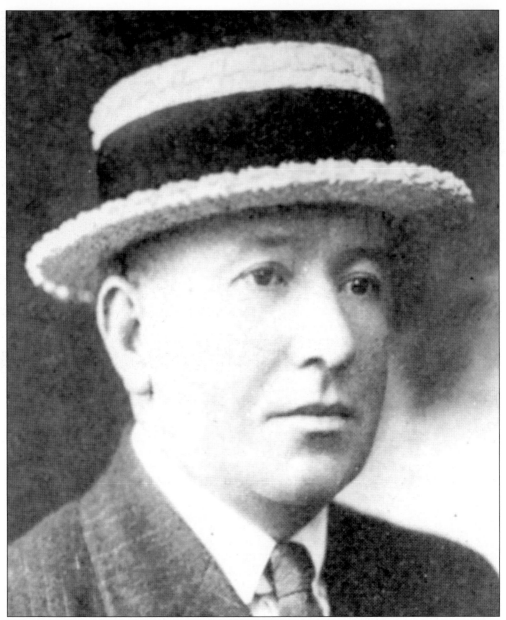

Francis J. Boyle (1886–1940), seen in this 1923 photograph, was appointed a patrolman when he was 21 years old. After more men had been added to the department, Boyle was made a sergeant in 1910. He was promoted to the first captaincy on June 13, 1913. When the Garfield detective bureau was established in 1917, Captain Boyle was put in command. During his term as captain of the uniform police, he was awarded the Wood McClave Medal for heroism for an outstanding arrest in 1915. Boyle single-handedly arrested four burglars in the act of breaking into a store on Passaic Street. However, most police work in the early days consisted mainly of patrolling the neighborhoods and enforcing the borough's blue laws. Fines were issued to anyone caught riding a bicycle on the sidewalk or to barbers who gave shaves on Sunday. On March 10, 1910, a student was fined 50¢ for not attending school. Only drugstores and ice-cream parlors were allowed to be open on Sundays. (Of course, all taverns had a back door.)

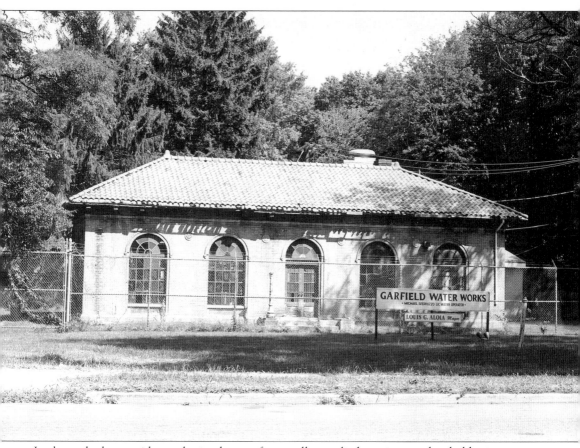

In the early days, residents obtained water from wells or relied on cisterns that held rainwater. As more inhabitants moved into the community, merchants established stores, and soon the need for fire protection became a steadily increasing concern, increasing the need for available water. The citizens petitioned Saddle River Township for its own water supply, but the request was denied. A private corporation then drilled a well and started a pumping station on Grand Street. When the borough purchased the small plant a few years later, it marked the beginning of the present municipal-owned water supply. The arrival of large industry created even greater demands for water, and additional wells and pumping stations were added. However, by 1924, it became clear that in order to meet increasing demands for water, the city would have to invest in a large water development program. The Garfield Water Works (pictured) was erected in neighboring East Paterson (Elmwood Park) in 1925 at a cost of $1 million and had a capacity of three million gallons per day.

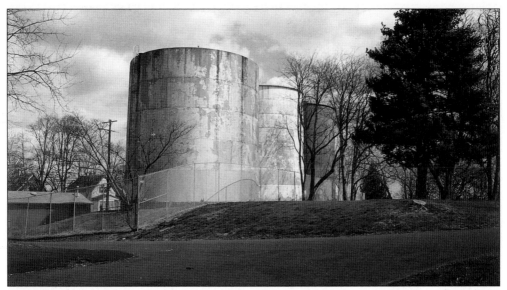

In addition to supplying an adequate volume of water, there were problems maintaining sufficient water pressure in certain areas of town during peak demand periods. In 1951, water pressure to the second ward was increased when a third water-storage tank was erected on Belmont Hill and a booster station was built on Botany Street to keep the tanks filled. A huge water-storage tower was later erected on Harrison Avenue to alleviate low water pressure problems experienced by residents in the third ward.

This photograph was taken on November 25, 1967, at the open house for the first anniversary of the Garfield Volunteer Ambulance Corps. Shown are, from left to right, Capt. Al Perrelli, Lodi Ambulance Corps; John Rozema, president of the Garfield Corps; John Danis, chief of the Garfield Corps; and James Smith, first aid instructor for Garfield. The apparatus being shown to the Lodi squad captain is a port-power unit that could rip a car door open in 10 seconds. (Courtesy Mary Danus.)

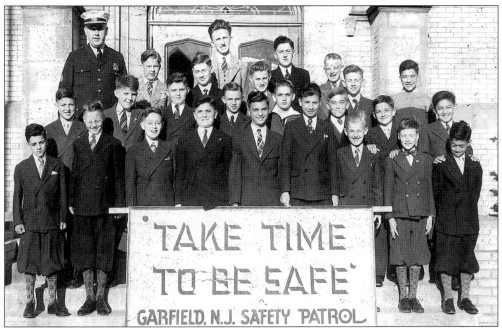

Seen in this 1938 photograph is Capt. Byron Christie (back row, left) with the patrol boys of School No. 7. The Garfield Junior Police Safety Patrol was organized in the grade schools on Valentine's Day 1938 to assist younger pupils crossing intersections as they walked to and from school. In 1940, the Garfield patrol boys won the North Jersey Auto Club's silver loving cup for being the neatest appearing New Jersey group in their parade in Washington, D.C. (Courtesy Mark Pedone.)

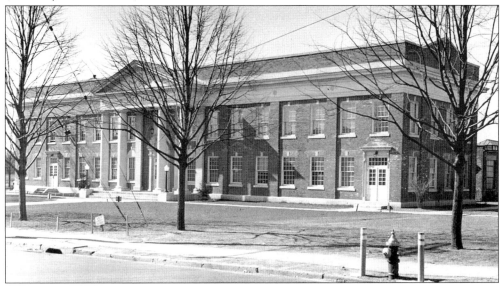

The Garfield Worsted Mill erected the building that is now Garfield City Hall as a cafeteria and day nursery for their employees in the early 1900s. When the mill closed shortly after World War I, the building was used by the city as a recreation center called the City Casino. In 1940, the city began renovating the building, and on August 24, 1941, the building was dedicated as Garfield City Hall.

Joseph J. Novack was appointed city clerk on February 10, 1920, five days before his 21st birthday. "I guess I hadn't even voted yet when I took the job as clerk," Novack once said. His first office was in the old city hall at the corner of Midland Avenue and Somerset Street. He worked there without any assistants until shortly before the office was moved to the present building on Outwater Lane in 1940. During his 39 years as city clerk, Novack served with 10 mayors, from William A. Whitehead through Joseph Kobylarz, and was for many years de facto city manager. Also during this period, he witnessed the population grow from 19,000 in 1920 to about 30,000 in 1959, the year he resigned his position due to poor health. Few individuals have served their community as long and as loyally as did Joseph J. Novack. (Courtesy Mark Wallace.)

Five

AROUND TOWN

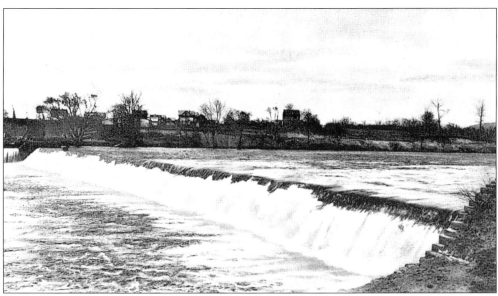

The Dundee Dam is viewed from the Garfield side of the Passaic River c. 1910. The cornerstone was set in place on April 20, 1859, and construction was completed about a year later. Locally quarried red sandstone blocks, approximately one foot thick, were placed in a series of steps to build the dam, which is 450 feet wide and has a drop of about 12 feet. A single and a double water-control gate were then installed on the western end of the dam to supply water to the raceway (Dundee Canal) for the mills downstream.

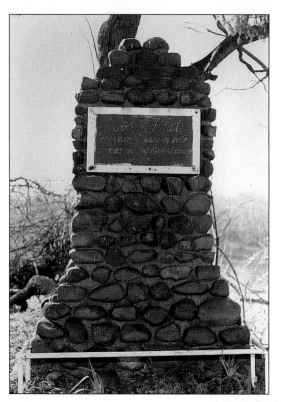

The Post Ford Monument, standing on River Drive near Columbus Avenue, marks the site where British and Hessian soldiers crossed the Passaic River from Garfield on November 26, 1776, in pursuit of Washington's army. In 1935, Francis L. Fuscaldo was principal of Public School No. 4 and spearheaded a drive to create a permanent marker at the site. Pupils at the school collected pennies to pay for construction materials as volunteers gathered stones from the riverbank and labored to construct the nine-foot-high monument.

This sketch of the monument was made by Fuscaldo and mailed to John Poltorak, who helped design the monument. The letter is postmarked May 29, 1935, the day of the dedication ceremony. The iron plaque affixed to the monument reads, "Post Ford— Frequently used by both armies during the Revolutionary War."

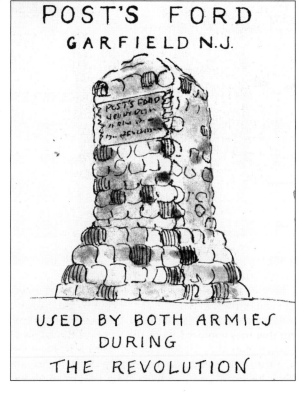

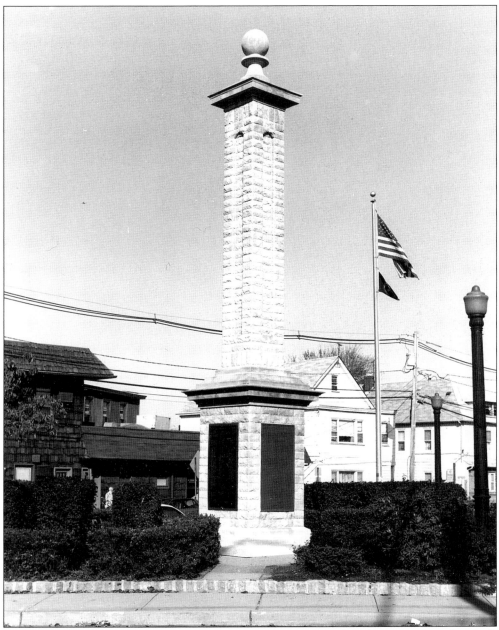

The Veteran's Monument (originally named the Soldier's and Sailor's Monument), which stands at the intersection of Marsellus Place and Midland and Harrison Avenues, was erected shortly after World War I as a tribute to city residents who sacrificed their lives for their country. The 35-foot obelisk masonry structure was dedicated on July 4, 1920. Several disputes erupted at the end of the ceremony over the context and design of the main tablet. Residents and former servicemen were outraged that the names of city officials were placed not only on the same tablet but that they appeared above the names of those killed in the war. A second dispute began when Councilman Max Klemm realized that his name was not on the tablet. Arguments went on for months until finally, on January 7, 1921, the council yielded to petitioning by the former servicemen and removed their names to a small plaque at the base of the monument.

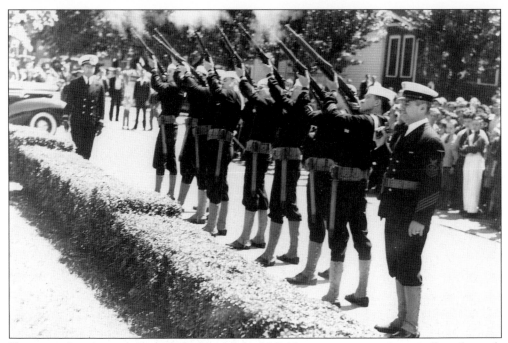

Shown in this photograph are eight men of the U.S. Navy preparing to fire a volley of rounds over the Veteran's Monument as a crowd of spectators gathers in the background to observe Memorial Day ceremonies in 1946.

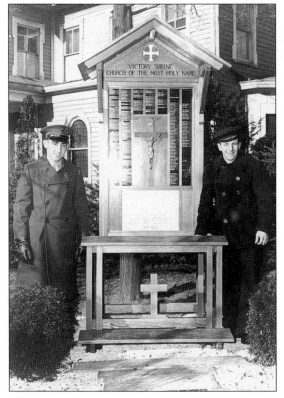

A soldier and sailor flank the Wayside Shrine, erected on the rectory grounds of Holy Name Church. The shrine was dedicated on December 5, 1944, to honor parish members who were then serving in the armed forces during World War II.

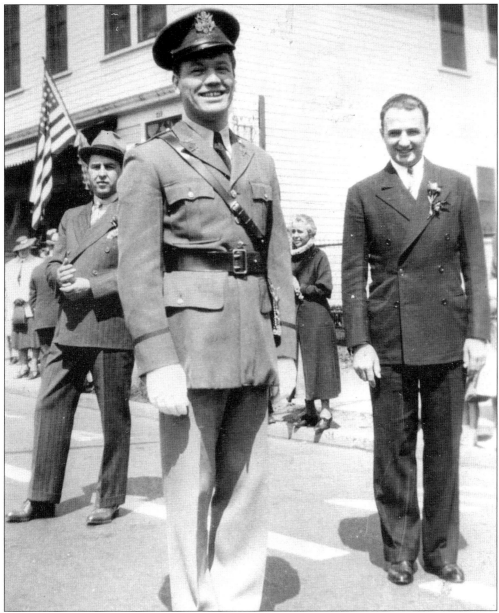

John M. Gabriel graduated from Garfield High School and went on to receive a degree in civil engineering at the Drexel Institute of Technology in Philadelphia. In November 1937, he won the mayoralty election and in doing so became the youngest mayor in New Jersey. World War II broke out during his administration, and Gabriel was immediately called into active service as an officer in the army reserve. Councilman Peter Cimino was acting mayor while Gabriel was in service. It was during Gabriel's first two terms that the Garfield Boilermakers won the National High School football championship game (1939). In 1940, the Holy Name Cadets won their first Junior National Drum and Bugle Corps competition, and the newly formed Garfield Junior Police Safety Patrol won the North Jersey Auto Club's Silver Cup award in Washington, D.C. Following these victories, Mayor Gabriel began calling Garfield the "City of Champions," and the phrase stuck.

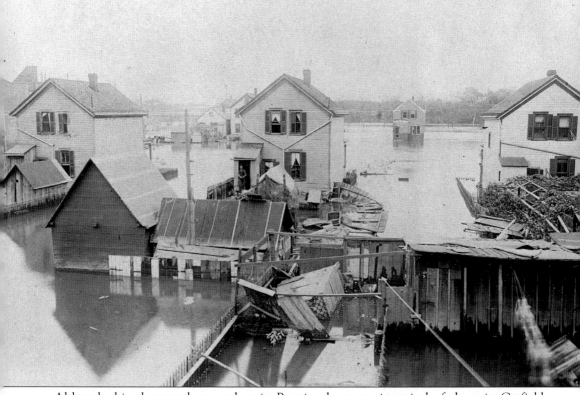

Although this photograph was taken in Passaic, the scene is typical of those in Garfield, Wallington, and Lodi following the Great Flood of 1903. On October 8, 1903, a steady downpour dumped more than 10 inches of rain in less than 24 hours, causing the river to swell to very dangerous levels. The river reached a record flow rate of 37,000 cubic feet per second and soon began to overflow its banks. Fences, chicken coops, small barns, and every other portable thing were carried away by the waters. The blacksmith shop, at the corner of River Drive and Passaic Street, was swept away, and the clubhouse of the Garfield Athletics was washed from its foundation and deposited at the rear of Vander Platt's funeral home. Civil engineers were greatly relieved, if not amazed, to see that the Dundee Dam withstood the powerful forces of the raging river.

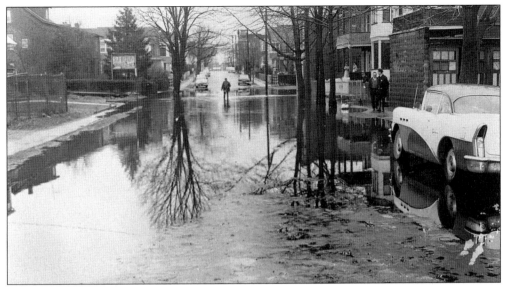

This area at Division Avenue near Jewell Street flooded in the 1958 storm. Heavy rains would frequently cause Fleischer's Brook to overflow its low banks and spill onto the streets and basements of nearby homes and stores. Repeated flooding forced some storeowners on Jewell Street to go out of business and a few residents to move out of the area. The city corrected the problem in the 1980s by diverting a portion of the water flow to the Passaic River.

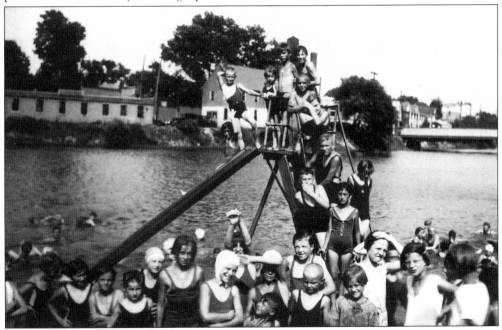

A group of area youths takes a moment to pose for a photograph at the homemade slide in the Passaic River. The photograph was taken in 1934 and brought to a drugstore on Passaic Street, where it was apparently misplaced and never developed. In the 1990s, the missing roll of undeveloped film was discovered while cleaning out the basement of the old drugstore building. When developed and printed, the images were amazingly well preserved after more than 60 years. (Courtesy Judy Messineo.)

Anna Marchesano Bosco entered the Newark School of Maternity at Jersey City's Margaret Hague Hospital in 1921. Upon completion of her training, she received her license from the Medical Examiners of New Jersey for the "practice of midwifery." By 1924, she was delivering at least four babies a day. Her regular fee for services was $20, but she would help needy families with food and free medical services when they could not afford to pay.

A canine tax was imposed in March 1907. Joseph "Rattlesnake Chuck" Valuzzi of Lincoln Place was appointed as the borough's first dogcatcher and was paid 50¢ for each unlicensed dog he brought to the pound. Soon, dozens of dog owners began complaining that their dogs had been stolen. Bewildered officials investigated and learned that Valuzzi was not only picking up dogs that were running loose but also was going into yards and taking unlicensed dogs out of their coops.

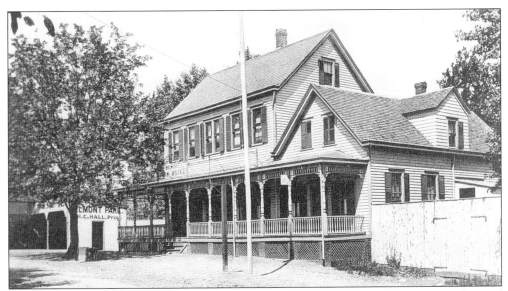

Ottomar Barthold, who owned the Octagon House at one time, built the Belmont Park Hotel (later the Belmont Ballroom) on River Drive near Belmont Avenue in 1898. A few years later, Harry Clinton Hall sold his saloon at 108 Jewell Street and purchased the Belmont Park Hotel. Hall expanded the picnic grounds and added a skating rink.

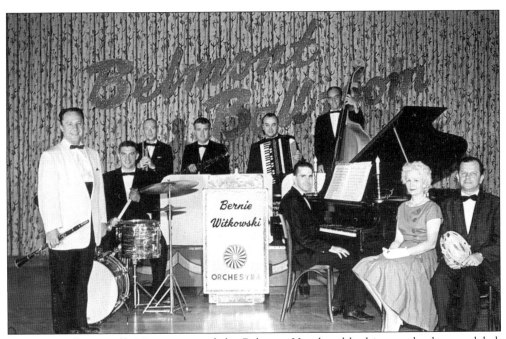

In 1938, William "Billy" Butts acquired the Belmont Hotel and had it completely remodeled. Throughout the 1940s and 1950s, the New Belmont Ballroom was one of the most popular dance spots in the area, second only to that of the Polish People's Home across the river on Monroe Street in Passaic. Bernie Witkowski's orchestra, shown in this *c.* 1950 photograph, frequently appeared at both dance halls. During the summer months, amateur and semiprofessional boxing matches were frequently held at the boxing arena located on the picnic grounds.

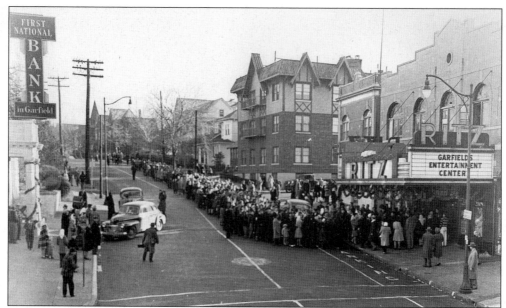

In 1947, Clifton photographer George Holm captured the only known photograph of the Ritz Theater. In this scene, a crowd awaits the arrival of Santa Claus. Children, accompanied by their parents, lined Passaic Street from the theater all the way to Marcellus Place. The First National Bank, sponsors of the event, arranged to have Santa flown in by a helicopter that landed near the intersection of Marsellus Place and Passaic Street.

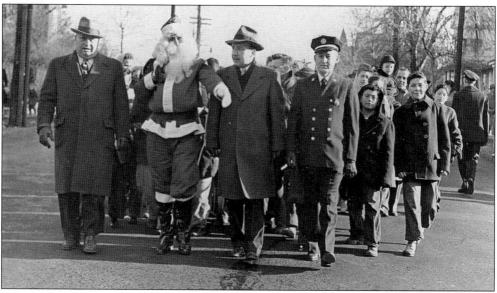

Police Chief Nicholas Perrapato, Santa, Mayor Ernest Branca, and Fire Chief Ted Vagell lead the parade down Passaic Street to a crowd of 3,000 children awaiting the arrival of Santa at the Ritz Theater in 1947. About 1,500 children, the theater's capacity, were permitted to go inside for the party, where they received gifts and candy from Santa and Bob Emery, host of the then-popular *Small Fry Club* television show.

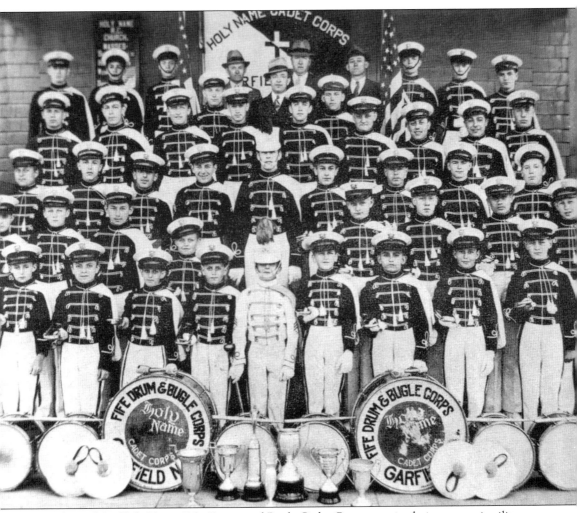

Members of the Holy Name Fife, Drum, and Bugle Cadet Corps pose in their new semi-military uniforms on the steps of Holy Name Church on Marsellus Place. A short time after this 1936 photograph was taken, the cadets eliminated the fifes in order to enter field competitions with other drum and bugle corps. The Holy Name Cadets, later the Garfield Cadets and now the Cadets of Bergen County, are the oldest and most honored junior drum and bugle corps in the world. The corps was organized in the winter of 1934 from parishioners of Holy Name Church. By 1938, they had earned the distinction and fame as a class A junior drum and bugle corps and were invited to perform at the 1939 New York World's Fair. In 1964, the corps won its 10th American Legion National Junior Drum & Bugle Corps Championship, an achievement that to this day has not been equaled by any other corps in the country.

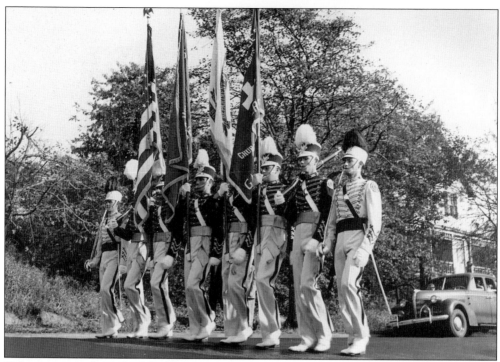

Color bearers and guards of the Holy Name Cadets Junior Drum & Bugle Corps wear the cadet-style uniform that they began using in 1941 after receiving permission from the West Point Military Academy to copy the style of its parade uniform. The attractive white, maroon, and gold uniforms have remained virtually unchanged to this day.

Several newspapers were published in Garfield, including the *Home Friend* (1890), the *Garfield Dispatch*, and the *Garfield Record* (1898), but all lasted only a few years. On January 1, 1917, former New Jersey senator Ralph Chandless and his brother Harry published the first issue of the *Garfield Guardian* at 121 Midland Avenue. Gerard DeMuro later became editor of the weekly newspaper and continued the weekly publication until 1976.

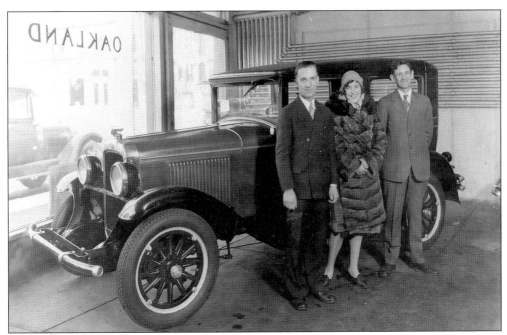

This 1928 photograph was taken in the showroom of the Garfield Auto Sales Company at the corner of Passaic Street and River Drive, where Franchini Chevrolet is now located, and shows the winners of the first, second, and third prizes in the *Garfield Guardian*'s circulation contest. They are standing in front of a 1928 Pontiac sedan, the first prize, won by Edward C. Kornhoff (right). Peter Regal (left) won a 1928 Ford sedan as second prize, and Mrs. William Seifert won third prize, a $100 diamond ring. The word Oakland on the showroom window refers to the name of the company that introduced the Pontiac in 1926.

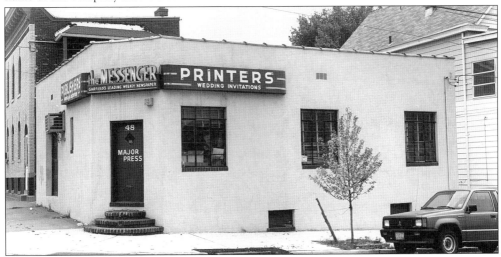

The *Messenger* was formerly *Il Messagero*, an Italian paper that was published in Paterson, New Jersey, starting in the 1920s. Peter J. Yuppa borrowed some money in 1938 and purchased *Il Messagero*. In 1940, he teamed up with Louis J. Vorgetts, changed the name to the *Messenger of Garfield*, and began printing the newspaper in English. A year later, the entire operation moved into this building at the corner of Harrison Avenue and Lincoln Place in Garfield, where the paper continues to be published weekly.

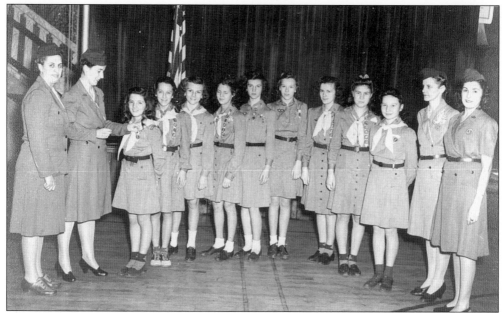

In the 1940s, when this photograph was taken, the Garfield Girl Scouts belonged to the Clifton-Passaic-Wallington Garfield Council (later the Lenni Lenape Council) of the Girl Scouts of America. The scouts' summer camp in Sparta was named Camp Clipawaga, an acronym for the names of the four towns that made up the council. These scouts line up to receive badges that were earned for the development of skills as well as knowledge that is possibly helpful to others.

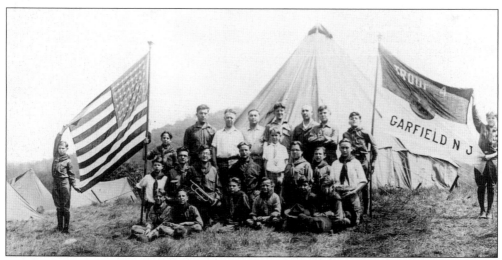

Paul Cardiello, a school custodian for many years, organized the first formal Boy Scouts of America troop in Garfield in 1923. In June 1923, scoutmaster Cardiello purchased 24 shelter tents at $1.50 each and 4 scout axes at 50¢ each from the Army and Navy Outlet Store on Prospect Street in Passaic. Cardiello is in the back row, third from the left, in this c. 1924 photograph taken at Camp Oakland. Former police chief Carmine Perrapato was one of the first to join Troop No. 4.

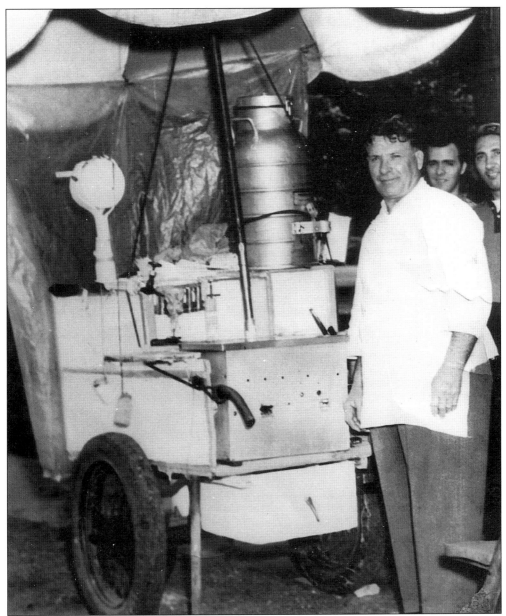

Unlike the hot dog vendors who park in one spot all day, Sebastian Zangara, an Italian immigrant, pushed his hot dog wagon all around Garfield during the middle of the 20th century. In later years, he parked his wagon at the corner of Midland Avenue and Outwater Lane. His son Tom recalled people giving directions to city hall by saying, "Go to the hot dog man and turn left onto Outwater Lane." Sebastiano stands at his cart in this 1970s photograph. Some may remember the distinctive-sounding bell at the side of his cart that was made from a discarded brake drum or the hand-carved, wooden mustard spreader. The white, banjo-shaped object mounted on the cart was a kerosene lamp that Sebastiono installed in order to avoid being struck by passing cars at night. For years, people tried unsuccessfully to figure out the secret recipe that made his hot dogs taste so good. When asked outright, he would just smile and politely shake his head. (Courtesy Thomas Zangara.)

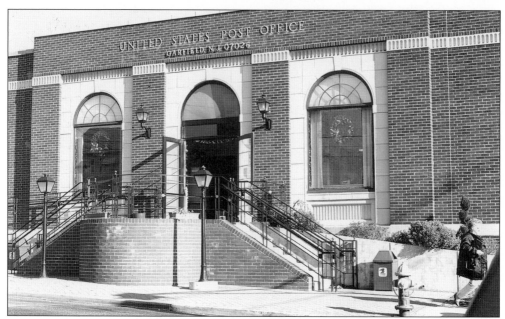

The first post office in Garfield was established on August 7, 1882, in the Whitehead building on Passaic Street with Nicholas G. Vreeland as postmaster. On February 1, 1902, it was discontinued as an independent office and became a station of Passaic. In 1922, the location was changed to the First National Bank building and, in March 1928, was made an independent office by the U.S. Post Office Department. The present federal building was erected in 1935 at the corner of Palisade and Van Winkle Avenues and now houses the post office.

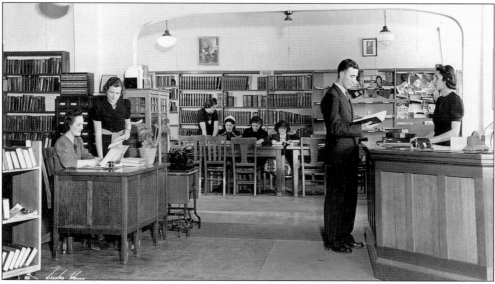

The first public library in Garfield was established on February 2, 1923, in a small store located on Palisade Avenue near Grand Street. Needing more space, the library was moved to two rented storefronts on Belmont Avenue. Olga Katz, Garfield librarian for 50 years, stands at the desk on the left in this c. 1935 photograph. In 1941, Katz coordinated a campaign that led to the establishment of the library as an official entity of the city. The present library was built on Midland Avenue in 1967.

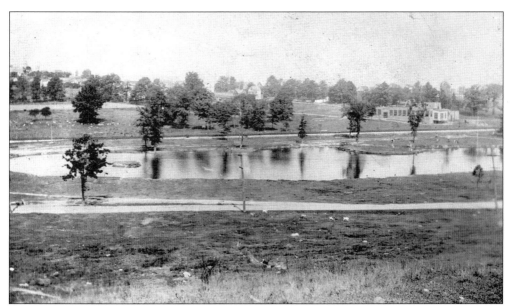

The lake seen in this c. 1920 photograph was, for many years, called Pump House, in reference to the old water-pumping station that was built nearby. In earlier days, the shallow pond was the favorite, and possibly safest, place to go ice-skating in winter. On July 23, 1938, the lake was dedicated as Dahnert's Lake Memorial Park, in honor of former mayor Ernest B. Dahnert. The county now owns the 9.53-acre site that is an oasis in an otherwise very densely developed urban landscape.

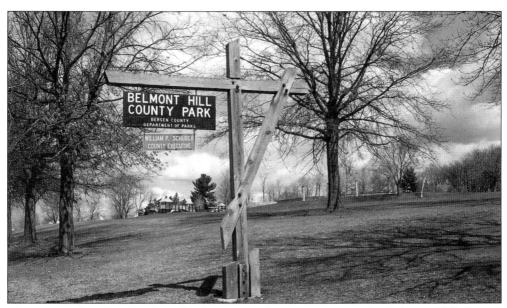

The sign in this photograph marks the Botany Street entrance to the Belmont Hill County Park. Garfield conveyed the nine-acre site, known locally as Belmont Hill, to Bergen County, which established the first Bergen County Park here in 1950.

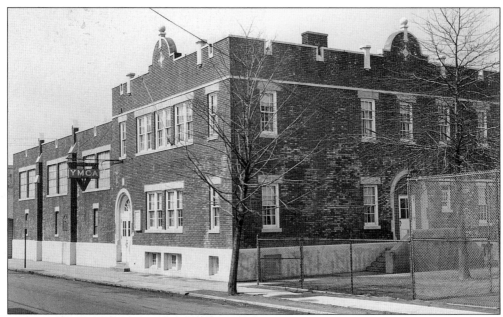

The Garfield YMCA was first established in the storefront of a building on Palisade Avenue near Van Winkle Avenue in 1923. After woolen mill magnate Samuel Hird died in 1922, his will bequeathed money and a portion of his property along Outwater Lane for the purpose of erecting a YMCA building as a gift to the citizens of Garfield. The YMCA building, shown in this *c.* 1940 photograph, was built in 1926 at a cost of $135,000.

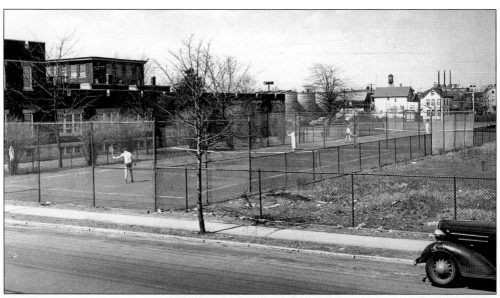

The YMCA's tennis courts, shown *c.* 1940, were located where the parking lot now stands. The original courts were made using clay dug from the old brickyard at the corner of Semel and Palisade Avenues, then carried by wheelbarrow to the YMCA and spread over the ground. The clay was then pressed smooth using heavy, water-filled rollers in much the same manner as asphalt paving is done today. (Courtesy Garfield YMCA.)

Standing outside the YMCA building c. 1947 are Vesta Smith, secretary of the women's division from 1947 to 1953, and John Pace, executive secretary of the Garfield YMCA during this same period.

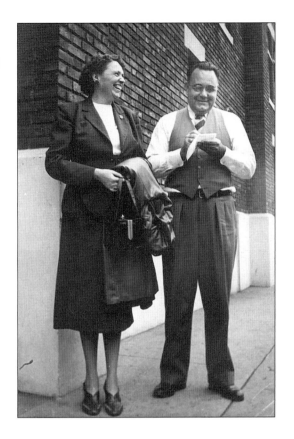

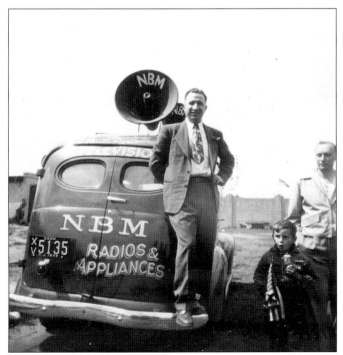

Nicholas B. Madonia stands on the bumper of his 1949 panel truck while his son, Nicholas Jr., and an unidentified school official look on. Madonia, who owned a radio, television, and appliance store on Outwater Lane, converted one of his delivery trucks into a public address system. His mobile sound system was used at sport, social, and political events and, at times, would travel through town to alert citizens of a water emergency or on Election Day to remind people to vote. (Courtesy Angie Madonia.)

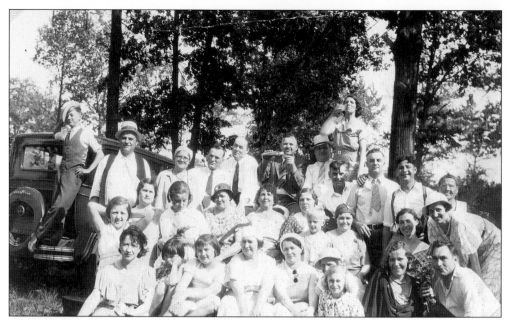

Friends and neighbors pose for this 1932 photograph of a summer picnic at the Garfield Water Works grounds in East Paterson (Elmwood Park).

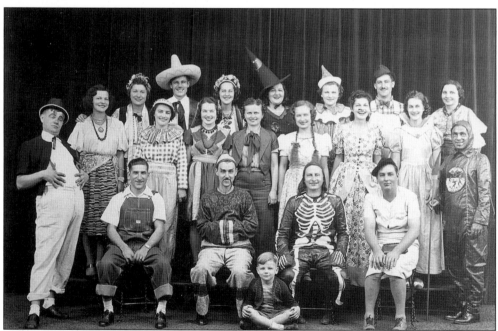

A group of friends and relatives dons costumes to celebrate Halloween in 1940. The party was held in the hall of Joe Monash's Moon Tavern, located at the corner of Wood Street and Lanza Avenue. Identified in the photograph are Joseph Monash (far left), Mae Heck (second from left), Frank Monash (wearing Mexican sombrero), John Heck (in Chinese costume), and Joseph Monash Jr. (seated in the foreground). (Courtesy Frank J. Monash.)

The Jersey Night Riders organized in 1928 at the home of Dino Savioli (founder of North Jersey Ravioli) and, by 1947, had gained the reputation of being the best motorcycle club in the East. Early members include Jack Larkin, Martin Winkler, Hugo Galler, Peter Vicary, Fred Toscano, Bob Scaturro, and Mario Abruscato. The club was a local sensation when it would perform its daredevil rides up the former steep slopes of the hill across from Dahnert's Lake. (Courtesy Geraldine Koch.)

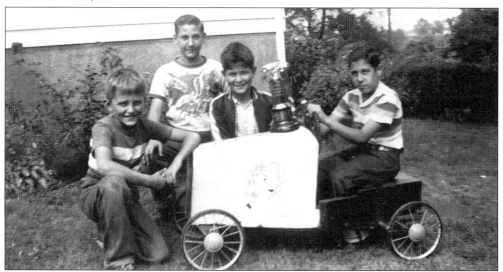

The first official soapbox derby in Garfield was held on September 5, 1946, and was a competition to see whose homemade car could coast down a quarter-mile stretch of the Cedar Street hill in the shortest time. Boys up to age 12 made up the junior group, and those aged 13 to 16 were placed in the senior group. Shown, from left to right, are Andrew Molchon, Leonard Mulé, Bushy Verga, and Howard Lanza, who won the Mayor Carmen Belli trophy in 1951.

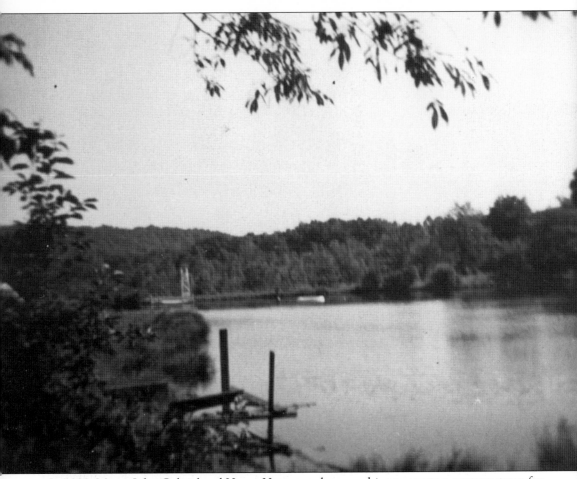

In 1938, Mayor John Gabriel and Henry Hartmann began a drive to create a summer camp for Garfield boys and girls. Approximately 40 acres of land off Paradise Road in West Milford, New Jersey, were purchased, and a campsite was built as a Work Projects Administration (WPA) project. A row of cabins, each with eight sleeping bunks, was built on the hill above the lake. The dining hall, camp canteen, post-exchange, and directors quarters were located on the lower section. Activities included swimming, boating, and fishing at the pond, hiking around the Clinton Reservoir, softball, volleyball, and arts and crafts on rainy days. All attended the daily raising and lowering of the American flag. Religious services were available on Sunday in the woodland chapel. The summer camp was dedicated on June 23, 1940, but activities and further improvements were halted during the war years. On July 11, 1948, the summer camp was rededicated as Camp Garfield. Shown in this c. 1950 photograph is the camp's man-made lake, nestled at the foot of the Bearfort Mountains.

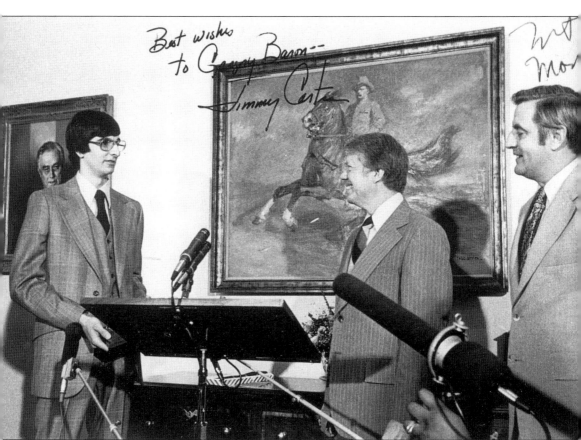

On March 30, 1977, Gregory Baron received the Boys Clubs of America National Boy of the Year award from Pres. Jimmy Carter and Vice Pres. Walter Mondale at a special White House ceremony. Baron was chosen from among one million members of the Boys Clubs of America. Among his many accomplishments were his impressive scholastic credentials and his position as student government president, National Honor Society treasurer, *Quill* newspaper editor-in-chief, varsity basketball team captain, and first in his class, maintaining a perfect academic average of 4.0. Baron was also an active member of the youth group of his church and a source of great strength for his mother, especially after his father's sudden death during his freshman year at Garfield High School. He continued his education at Princeton and went on to earn a degree from Fairleigh Dickinson University's College of Dental Medicine. (Courtesy Gregory Baron.)

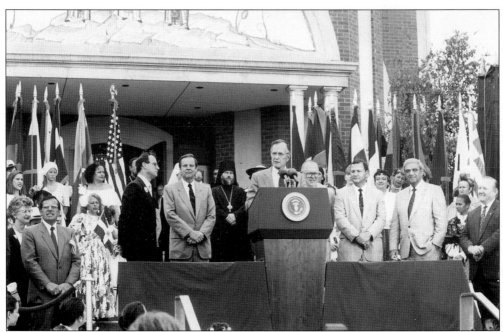

On July 21, 1992, Pres. George Bush, the first sitting president to visit Garfield, spoke in support of freedom for all the world's people and declared the day National Freedom Day. A crowd of 6,000 people assembled in the sun-baked parking lot of the Russian Orthodox Greek Catholic Church of the Three Saints to hear the president's 30-minute speech. Former New Jersey governor Thomas Kean (seen in the gray suit at the left of the president) had invited President Bush to speak at Three Saints Church. (Courtesy Drew Pavlica.)

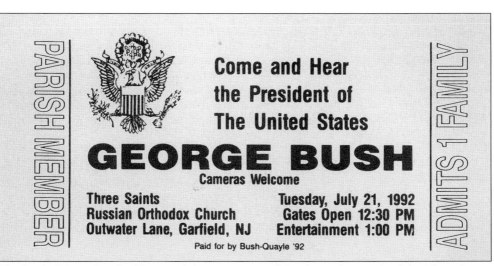

PARISH MEMBER

Come and Hear the President of The United States

GEORGE BUSH

Cameras Welcome

Three Saints
Russian Orthodox Church
Outwater Lane, Garfield, NJ

Tuesday, July 21, 1992
Gates Open 12:30 PM
Entertainment 1:00 PM

Paid for by Bush-Quayle '92

ADMITS 1 FAMILY

The beautiful, modern buildings and the spacious, well-landscaped grounds of the Three Saints Church were influential in the selection of this site for President Bush to make his speech. These special admission tickets were issued to parish members so that they would have access to preferred seating locations.

Six

THE CORNER STORE

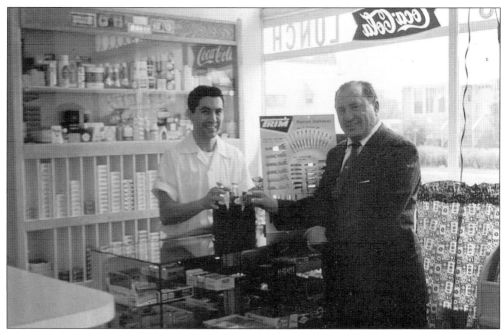

Lou Pizzi waits on customer Frank Ricciardi in his newly opened luncheonette at the corner of Harrison Avenue and Elizabeth Street in 1961. Pizzi's parents, Anthony and Josephine, owned and operated a grocery and chicken store here for many years. When his father decided to close the store, Pizzi began thinking about utilizing the vacated store to start his own business. He built the counter and showcases and, within a few months, opened Mary-Lou's Luncheonette. (Courtesy Mary Pizzi.)

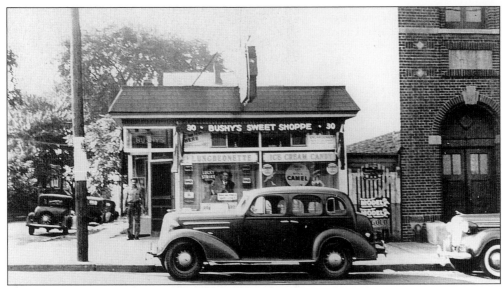

This 1930s photograph of Bushy's Sweet Shoppe captures the style and size of the typical neighborhood corner candy store and soda fountain of the period. William Bush (no relation to the first mayor of Garfield) owned property on Passaic Street where Michelle's Restaurant now stands. The buildings of Gortz's Drugstore, Schoonhen's Bakery, Lemberg's Delicatessen, and Weissberg's Fruit Market were all erected on land once owned by Bush. (Courtesy Dorothy Zivitsky.)

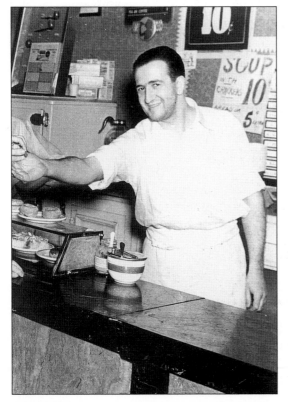

William "Bushy" Bush is seen behind the counter of his store in this c. 1930 photograph. Bushy owned and operated one of the earliest candy and ice-cream stores in Garfield, at the southwest corner of Passaic Street and Cambridge Avenue. (Courtesy Richard Malicky.)

This 1946 photograph was taken shortly after Anita "Babe" Laiosa opened Babe's Sweet Shop on Jewell Street. Her father, Anthony "Tony" Laiosa, made his own ice cream and lemon ice, which soon became popular and was bought by many of the area's stores and restaurants. Ann Sangis (left) and Babe Liosa are serving delicious ice-cream sundaes. (Courtesy Anita Laiosa Chimka.)

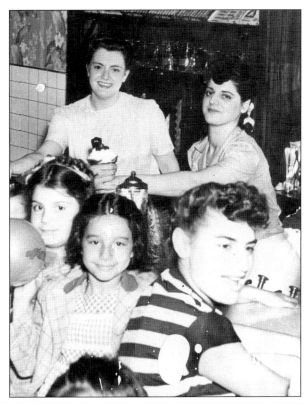

PIGGLY - WIGGLY
44 Plauderville Avenue

Self-Service **5 FOOD DEPTS.** **Phone: Passaic 2-1435**

SANKA or KAFFEE HAG 30c	Largest Can PEACHES 12½c	No. 1 Fruit Cocktail 10c
Hecker's FLOUR 99c	Minute TAPIOCA 10c	RINSO 18c

Val Vita Tomato Sauce 4c

The Piggly Wiggly grocery store was actually a chain of self-service food markets that were headquartered in Atlanta, Georgia. On September 16, 1938, Stephen Miko opened the first Piggly Wiggly in Garfield at 44 Plauderville Avenue. This advertisement, from the *Garfield Guardian*, shows some of the items on sale for the week of February 2, 1940.

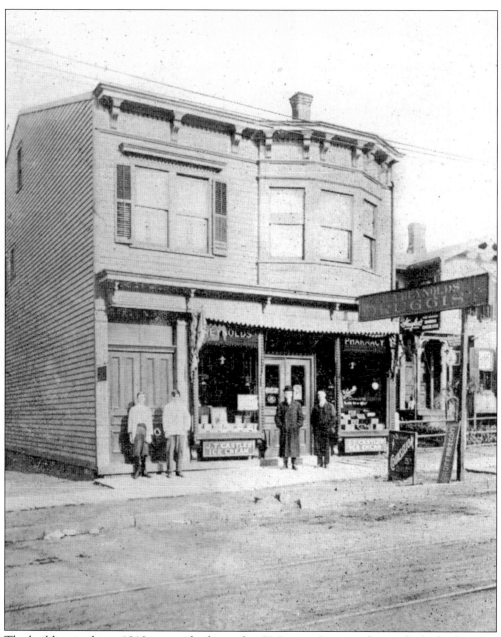

The building in this c. 1910 postcard is located at 73 Passaic Street and virtually looks the same as it did then. It was built around the beginning of the 20th century, and one of the first drugstores in Garfield was established here. Casper Bausch established the U.S. Pharmacy, one of the first drugstores in Garfield, c. 1904. The business failed a few years later, and the storefront remained empty for some time. In 1908, the First National Bank was organized and rented the store as a temporary office, until its new building was erected at the corner of Passaic Street and Midland Avenue. The next tenant was Bradley A. Reynolds, who purchased the U.S. Pharmacy, changed the name to Reynolds Pharmacy, and added a soda fountain. The advertising signs seen below both store windows read, "S.T. Castle's Ice Cream," a Garfield company that was later bought out by the Sealtest Company.

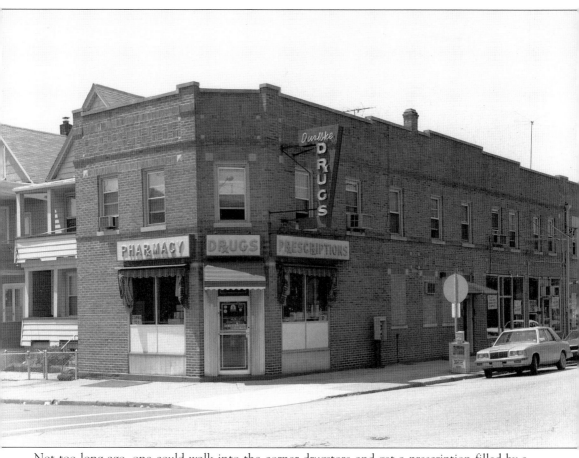

Not too long ago, one could walk into the corner drugstore and get a prescription filled by a druggist who knew you by name and also knew your doctor. He or she could explain in simple terms what you were taking and when and how to take the medicine. If you were homebound, the medicine would be delivered at no extra cost. One such corner druggist was Ronald Duriske, who graduated from Garfield High School and went on to earn his pharmacy degree. In 1957, he opened Duriske's Pharmacy, at 189 Palisade Avenue at the corner of Grand Street, where he continued in business for nearly 40 years. However, with the emergence of the large pharmacy chain stores during the early 1990s, Duriske and most other corner drugstores in town were simply unable to compete and eventually had to close their doors.

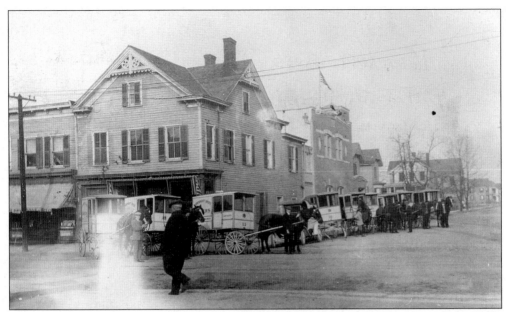

This early-1900s photograph shows the horse-drawn delivery wagons and building of Kornhoff's bakery at the corner of Passaic Street and Palisade Avenue. Clemens A. Kornhoff opened his first bakery in 1881 at the corner of Main Avenue and Jefferson Street in Passaic and later moved to Garfield. The heat from the large baking ovens in the basement kept the sidewalks at the corner free of ice and snow in winter; people would frequently stand there when waiting for a bus or just to meet and chat.

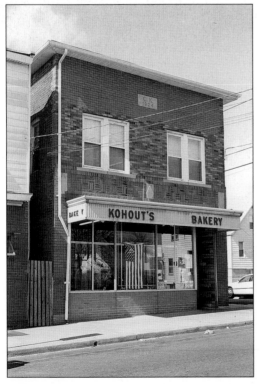

Kohout's bakery appears virtually unchanged from when the building was first erected in 1924. Charles and Josephine Kohout came to America from Czechoslovakia during World War I. In 1917, they established a bakery at 73 Jewell Street, next door to the current building. A second generation (also named Charles and Josephine) continued the business for many years. Now, Charles Kohout III runs the business that his grandparents began more than 80 years ago.

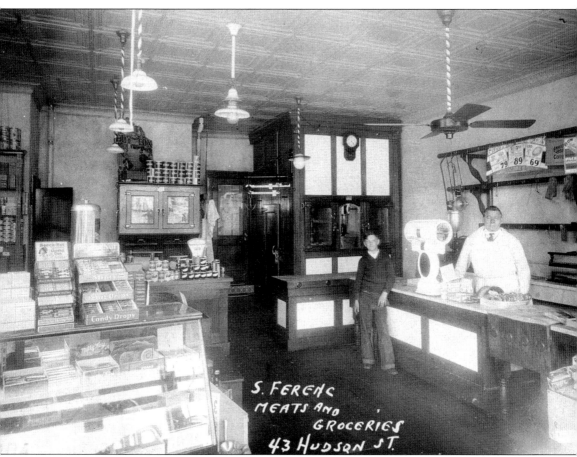

S. FERENC
MEATS AND
GROCERIES
43 HUDSON ST.

Stephen Ferenc, an immigrant from the Carpathian Mountain region of Europe, settled in Garfield and ran a grocery store at the corner of Cambridge and Grand Streets near the old water plant. In the 1920s, he purchased one of the last remaining empty lots in the neighborhood, built the multifamily dwelling at the corner of Hudson Street and Cambridge Avenue, and established the Ferenc Meats and Grocery store. Ferenc (standing behind the counter) and son John appear in this c. 1930 photograph. Barely visible in front of the cold room is a gas lamp hanging from the ceiling; the lamp was used for emergency lighting during electric power failures. Across from the Ferenc store was a large hill, called Watermelon Hill, where young fellows from Lodi and Clifton would meet to determine which group would be "king of the hill." The hill was removed at the start of construction of School No. 6. (Courtesy Michael Ferenc.)

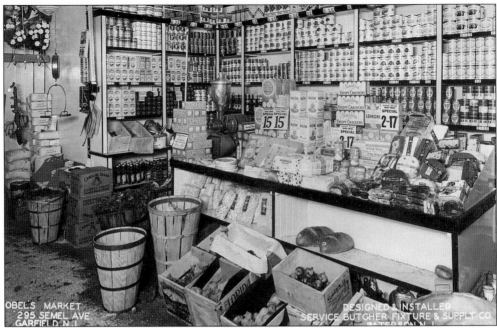

This c. 1930 photograph shows the large inventory in the grocery section of Obel's market at 295 Semel Avenue. The corner grocery and butcher shops that, at one time, were in nearly every neighborhood are now all but gone. Virtually all were owned and operated by a husband and wife team who lived in an apartment above or behind the store. Electric paddle fans, incandescent lamps, and strips of flypaper hanging from ornate tin ceilings were typical in early stores. (Courtesy Edward A. Smyk.)

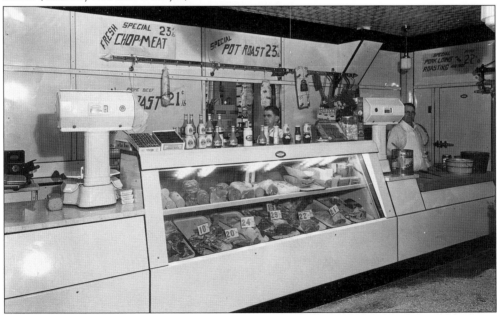

The owners of Obel's market are at work behind the counter c. 1930. The market was established in the late 1920s and had one of the most modern-equipped meat departments in Garfield. (Courtesy Edward A. Smyk.)

Seven

COMMERCE
AND INDUSTRY

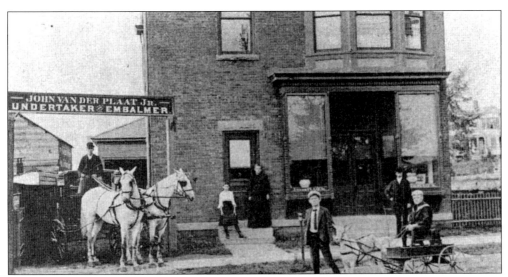

This late-19th-century photograph shows the funeral home established by John Vander Platt Jr. in 1894 at 7 Passaic Street, near River Drive. John looks on from the entrance doorway as his brother Frank holds the reigns of the horse-driven hearse. John's sons, John J. and Abraham, mimic the scene with their pony-drawn wagon. Mrs. Vander Platt and a daughter stand near the doorway leading to the family's second-floor apartment.

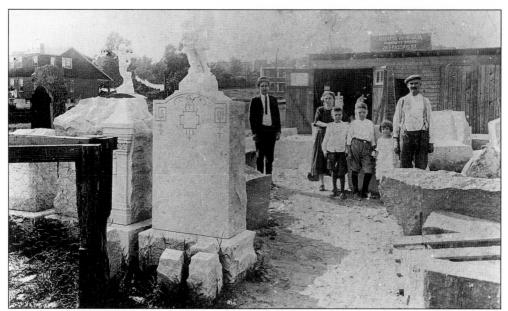

Rosario Imbruglia came to the United States from Italy and first settled in Vermont, where he continued his stonecutting trade. He moved to New Jersey and established the Rosario Imbruglia Monument Works at 267 Passaic Street in Garfield in 1921. Besides carving grave markers and monuments, the company produced the marble work surfaces for the pizzerias in the area. Identified in this 1920s photograph are Joseph Mobilia (brother of Concetta), Concetta Mobilia Imbruglia, Carmello "Teddy" Imbruglia, Violet Imbruglia, and Rosario Imbruglia. (Courtesy Imbruglia Monument Works.)

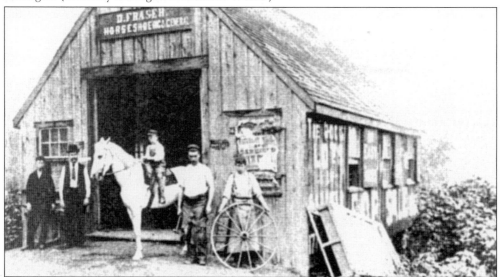

Donald Fraser, who lived on Palisade Avenue for many years, established a blacksmith shop at 12 Passaic Street at the beginning of the 20th century. A few years after this photograph was taken, the great Passaic River flood of 1903 carried away his shop and all its contents. Identified in this c. 1900 photograph are, from left to right, Alexander Pyott, William Pyott Sr., William Pyott Jr. (on horseback), Don Fraser, and his apprentice (holding wagon wheel). (Courtesy Garfield Historical Society.)

Wendel F. Roehrich settled in Garfield in 1895 and went to work in the Botany Mills in Passaic. He later purchased a parcel of land from the Van Winkle estate and built a large brick building, shown here, at the corner of River Drive and Belmont Avenue. Roehrich opened a tavern and boardinghouse here and then added a second building behind the tavern for use as a banquet hall. He then installed bowling alleys and billiard tables in the basement of the new building.

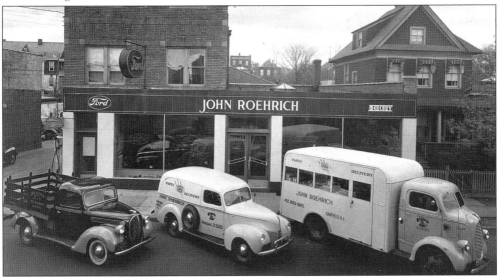

Wendel Roehrich's next business venture came in 1921, when he erected a third building at 450 River Drive and established a Ford automobile dealership. His son John later managed the business, which by that time had expanded to include a Mercury automobile franchise and an engine-rebuilding department. (Courtesy the Paterson Museum.)

JOHN ROEHRICH
Section of Parts Dept. and Showroom
"Largest Stock of Ford Parts in the State"
450 River Drive Garfield, N. J.
FREE DELIVERY SERVICE — Tel. Passaic 3-2520-1-2

This 1940 advertising postcard shows a section of the parts department and showroom of John Roehrich's Ford and Mercury dealership at 450 River Drive and boasts having the "Largest Stock of Ford Parts in the State." In 1948, Benedict J. Werner of Hackensack purchased the agency and renamed it B.J. Werner Ford Inc.

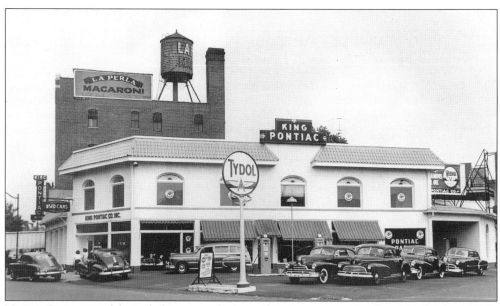

Various Pontiac models, including a wood-trimmed station wagon, are shown in this late-1930s advertising photograph of King Pontiac (now Franchini Chevrolet) at the corner of River Drive and Passaic Street. The "La Perla Macaroni" building seen in the background was originally built for the American Cigar Company.

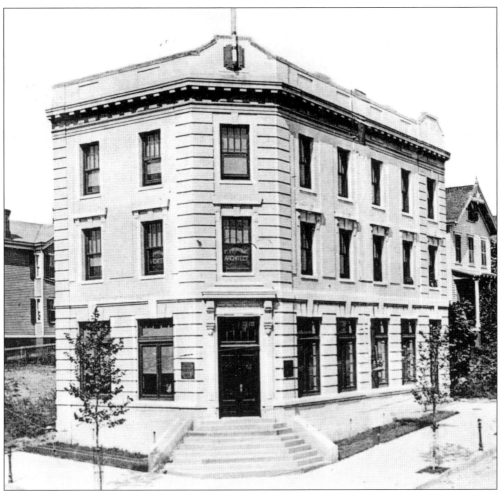

Prior to 1906, there were mainly building and loan–type banks in Garfield. Financial transactions that were possible only at larger banks had to be conducted in Passaic, Hackensack, or Lodi. The first major banking institution in Garfield was organized on December 8, 1906, when the First National Bank of Garfield opened for business in a rented building at 76 Passaic Street. Within a year, the bank had accrued more than $200,000 in assets, thus making it one of the leading banking institutions in Bergen County at the time. In June 1908, land at the corner of Passaic Street and Midland Avenue was purchased from Cornelius Warnaar of Garfield, and construction of the first three-story office building in the borough was completed in time for the grand opening on January 28, 1909. In 1933, the bank changed officers and, in 1934, was reorganized as the First National Bank in Garfield.

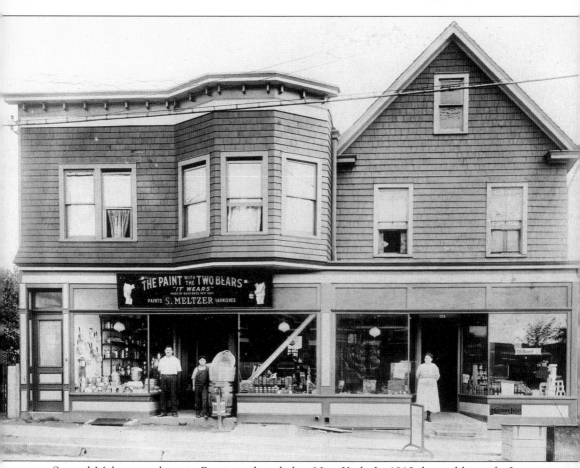

Samuel Meltzer was born in Russia and settled in New York. In 1913, he and his wife, Jennie, came to Garfield and started a general store, now a liquor store, on Outwater Lane. Many workers from the Garfield Worsted Woolen Mill, later Presto Lock Company, bought their lunch at Meltzer's. Both Jennie and Sam worked long and hard to build up the business. In 1922, Victor Eberhard was hired to construct a second building, which was used for the sporting goods department of the business. It was also here that they raised their four children, Hymie, Izzy, Ann, and Rose. Samuel Meltzer and son Hymie pose in this 1922 photograph in front of the new sporting goods store, and Jennie is at the entrance to the original store. (Courtesy Billy Meltzer.)

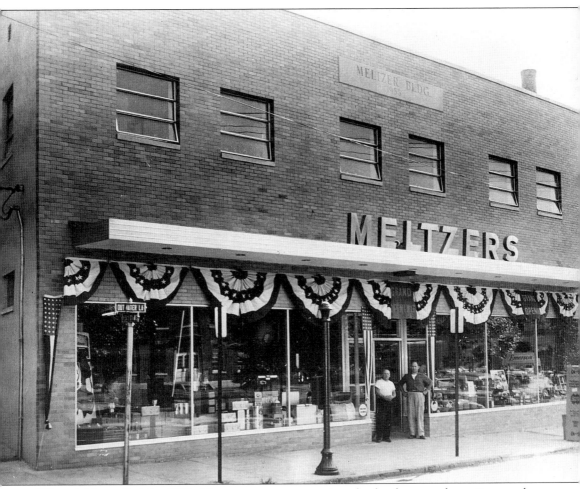

When Meltzer died in 1952, his two sons were running the hardware and sporting goods complex. Hymie and Izzy are seen in this 1955 photograph at the grand opening of the new Meltzer building, erected at the corner of Outwater Lane and Wessington Avenue. Eventually, the hardware department was phased out in favor of the rapidly expanding sporting goods department. Some residents remember Izzy serving coffee and a prune Danish to customers on Sunday mornings or shouting "Seltzer for Meltzer" when Jennie would come into the store carrying two glasses of seltzer, as she did each afternoon. Today, the business continues under Billy Meltzer, grandson of Sam and Jenny, who is quick to point out that "once you shop Meltzer's, you'll go no where else sir." Meltzer's is one of the oldest family owned and operated businesses in the city. (Courtesy Billy Meltzer.)

Natale Olivieri started bottling carbonated fruit drinks in the mid-1920s. However, when he attempted to bottle a chocolate drink, he found that it would soon spoil. Observing his wife canning fruits and vegetables, he asked her to use the same heat processing technique with his chocolate drink. It worked! He began bottling the pasteurized chocolate drink he named Yoo-Hoo at 113 Farnham Avenue in 1928. One day, Olivieri met Yogi Berra on the golf course, and they became immediate friends. Yogi endorsed the drink and sales skyrocketed.

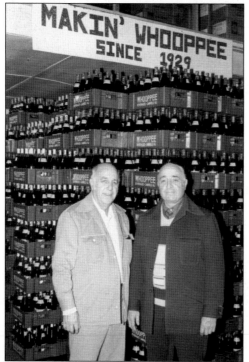

Antonio and Maria Graceffo established the Whoopee Soda Works at 99 Westminster Place and later moved to 196 Van Winkle Avenue. After Antonio died in 1934, Maria and her five children continued the business. Seen in this 1978 photograph are Ciro (left) and Gerlando, who became co-owners of the company after the death of Maria in 1969. Sarsaparilla was the first of some 30 flavors bottled under the Whoopee and Ciro trade names. The company name triggered slogans like "The only thing more fun than making Whoopee is drinking it." Closed since 1984, the company has been restarted by great-grandson Anthony J. Graceffo.

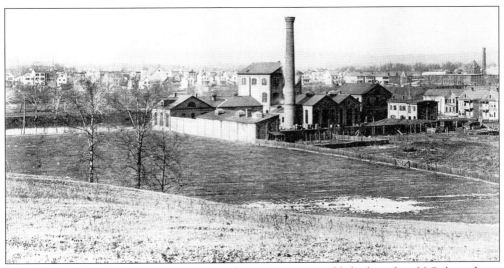

In 1872, the German-owned Fritsche Brothers company established its first U.S. branch on Weasel Brook near Third Street in what is now Clifton. There, the company extracted fragrant oils and perfumes from flowers grown in its rose gardens in Germany. In 1892, "Mayor" Gilbert Bogart enticed the company to build a plant at the corner of River Drive and Monroe Street, seen in this *c.* 1899 photograph. (*News' History of Passaic*, William Pape, 1899.)

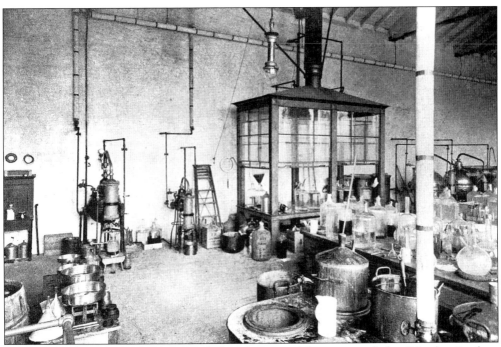

This 1899 photograph shows one of the chemistry laboratories of the Fritsche Brothers Company where fragrant oils, extracted from rose petals, were refined to make perfume. (*News' History of Passaic*, William Pape, 1899.)

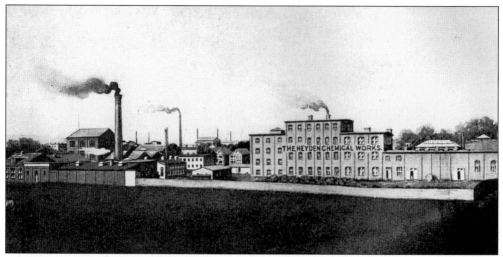

In 1901, the German-based Heyden Chemical Company purchased the land and buildings of the Fritsche Brothers factory and erected the additional buildings shown in this *c.* 1906 photograph. The land in the foreground is where the company later erected an office building and a large research and development facility. (*New Jersey: A Historical, Industrial and Commercial Review*, by Ellis R. Meeker, 1906.)

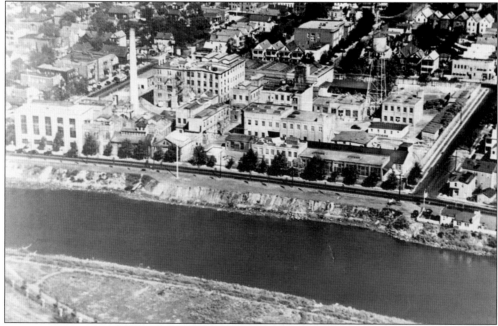

This aerial view of the Heyden Chemical plant was taken *c.* 1938 and shows the vast complex of buildings that occupied an entire city block. The Heyden plant manufactured formaldehyde (from natural gas), salicylic acid (used in the making of aspirin), resins, and other fine organic compounds. In 1943, Heyden was selected by the federal government to manage a $1 million facility established in Princeton, New Jersey, for the manufacture of penicillin.

106

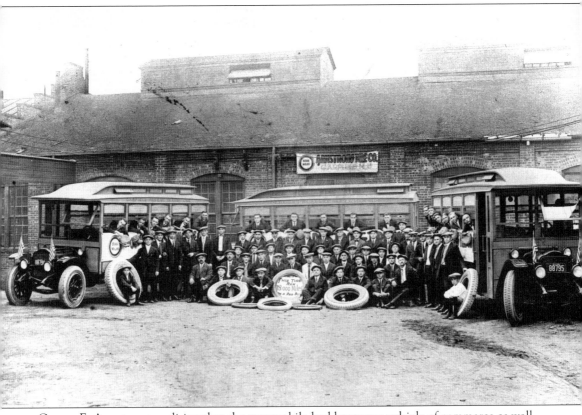

George F. Armstrong, realizing that the automobile had become a vehicle of commerce as well as pleasure, studied tire construction and, after several trials, succeeded in manufacturing a quality product. The Garfield plant, seen here, was built on the south side of Monroe Street between Midland and Pierre Avenues. When operations began in April 1919, the company employed about 150 workers and produced 500 tires and tubes a day. Employees of the Armstrong Rubber Company are seen in this *c.* 1920 advertisement photograph. The large truck and bus tires seen in the foreground were some examples of the company's product line. The young man in the center is holding a sign that reads, "This tire ran 18,000 miles on a Reo bus." (Courtesy Michael Ferenc.)

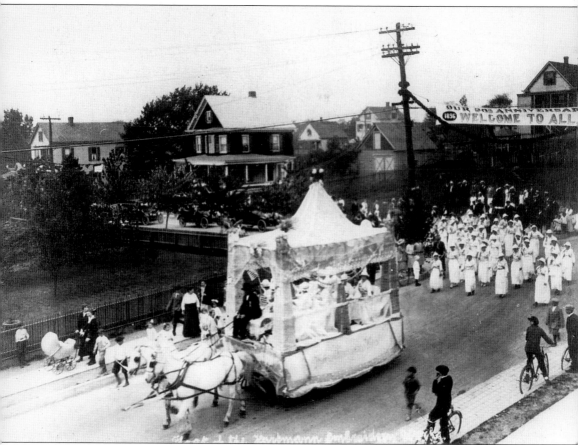

The Hartmann Embroidery Works was the first industry established in Plauderville. In 1896, Joseph Hartmann, who owned an embroidery factory in New York, moved to Garfield and built a 30- by 40-foot building behind his residence at 68 Plauderville Avenue. The Garfield plant was managed by his son Joseph Jr. and made only window curtains. In 1908, a new and much larger brick factory was erected at 62 Plauderville Avenue and is still standing. This 1926 photograph of the parade celebrating the 20th anniversary of the Hartmann Embroidery Works shows the company's horse-drawn float going down Outwater Lane as marchers make the turn from Prospect Street. During World War II, Hartmann's factory was the largest single manufacturer of military insignia in America. They made millions of uniform patches for all branches of the U.S. armed forces. The company also developed a way to produce Lastex, a puckered embroidered fabric used to make bathing suits and handbags that were once popular all over the world. (Courtesy Dr. Richard Schwimmer.)

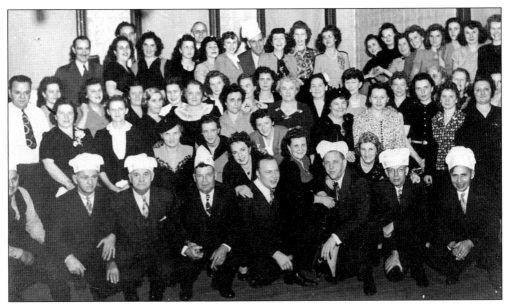

Employees and management of the Hartmann Embroidery Works pose at their 1947 company Christmas party. The five Hartmann brothers seen in the photograph are, from left to right, as follows: (front row) Henry, Jack, and Joseph; (third row, left) Ludwig; (back row, in chef's hat) Vince. Also identified are longtime employees Sophie Tylicke (second row, wearing hat), Mrs. Fritz (third row, with white collar), and Katherine Rabolli (right of Mrs. Fritz). (Courtesy Charles Rabolli.)

The main building of the Robertsford Worsted Mill was erected in 1892. James Roberts was born in Bradford, England, where he learned the manufacture of woolen goods. Upon coming to America, he established mills in Philadelphia and Maine before settling in Garfield. Roberts purchased a section of the old Outwater farm at the corner of Outwater Lane and River Drive and supervised the construction of this woolen mill. He set up the machinery and began to manufacture cloth using mohair and alpaca wool.

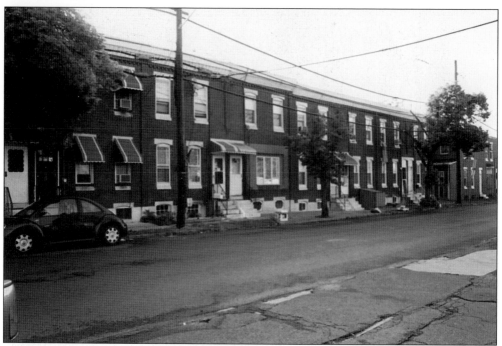

James Roberts built these 10 Philadelphia-style row houses on Jewell Street for his workers. His mill was the only one in Garfield to have adjacent housing for its workers.

Following the sudden death of James Roberts in 1896, Samuel Hird purchased the Robertsford Worsted Mills and founded Samuel Hird & Company. In its time, the company was one of the best-known manufacturers of medium-priced worsted fabric, which was primarily used for men's clothing. Sheep, symbolic of the industry, could be seen grazing on the front lawn of the mill, where the Dunkin' Donuts shop is currently located, before the mill closed in 1961.

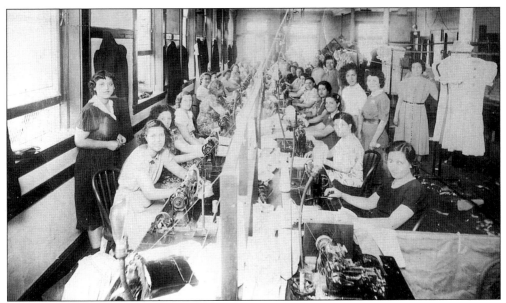

Operators sit at their Singer model 9540 sewing machines in the Style Dress Company, located at 38 Garfield Avenue, in the 1930s. Needlecrafts were an important part of Garfield's industrial history. This company, founded by Mario and Josephine Pedone, was representative of the more than 70 dress- and suit-manufacturing shops in Garfield that together employed about 2,500 workers. In those days, an employee was paid $1.06 per garment, and a skilled worker could make as many as seven dresses in one hour. (Courtesy Mark Pedone.)

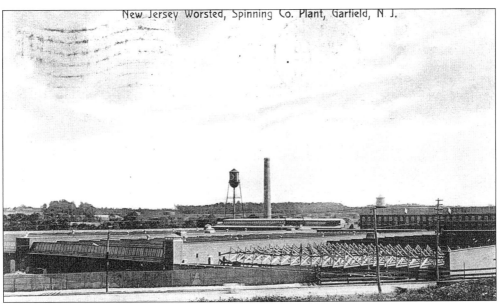

The mills of the New Jersey Worsted Spinning Company, shown c. 1910, were located on the south side of Passaic Street between Lincoln Place and the St. Peter Greek Catholic Cemetery. The German-owned company was incorporated in 1905 with Christian Bahnsen in charge. A $1 million mill complex was built on property purchased from Henry Marsellus and Daniel Van Winkle. In 1924, the company merged with the Gera Mills of Passaic.

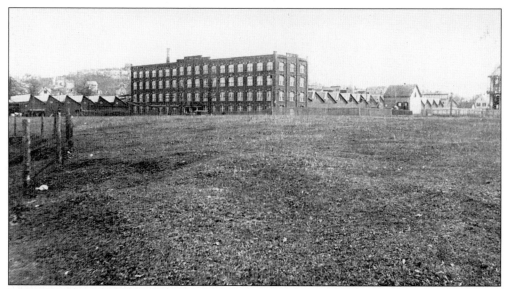

Julius Forstmann established his first cloth-weaving plant in America in 1904, when he opened the Forstmann Woolen Mill on Randolph Avenue in Clifton. This large new plant on Lanza Avenue opened in 1909. The spinning and weaving divisions were set up at this mill. During both world wars, the Forstmann mills produced quality woolens for the men and women of the armed forces.

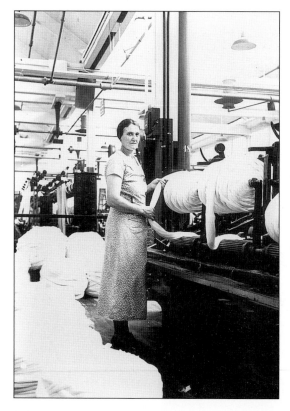

This 1932 photograph shows Mary Limberger Staudt working in the carding room, where the wool was cleaned, carded (to remove tangles), and wound into bales prior to spinning. (Courtesy Paul Staudt Jr.)

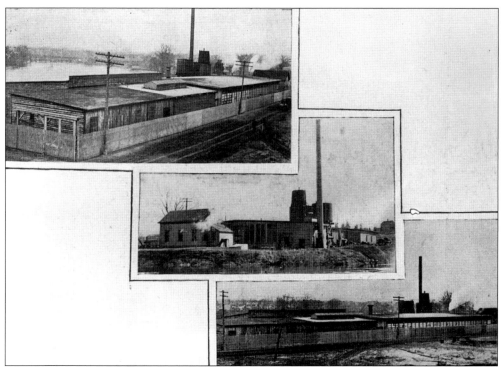

This *c.* 1899 photograph depicts the buildings of the Garfield Worsted Woolen Mills, erected in 1897 at 80 Outwater Lane. Access to water needed for its manufacturing processes was obtained by pumping water from the old brickyard pond that was located at the intersection of Semel and Palisade Avenues. The factory produced worsted wool dress goods and was an important part of Garfield's growing reputation as a textile-manufacturing center. (*News' History of Passaic*, William Pape, 1899.)

Recycling as we know it today did not yet exist when Richard Scudder had become dissatisfied with the waste of newspaper. He began looking for a way to remove ink from printed newspapers so that the remaining fibers could be formed into new paper. After years of trial and error, Scudder (seen at the center in this *c.* 1961 photograph) finally discovered a way to do it. In 1961, the Garden State Paper Company produced the world's first commercial roll of recycled newsprint at Scudder's mill along the Passaic River.

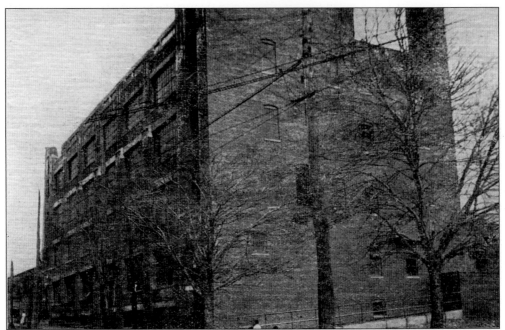

The large four-story, brick cigar factory at 18 Passaic Street is shown in the early 1900s. The American Cigar Company, and later Shram's Cigar factory, occupied the building, where hundreds of girls were hired to hand-roll cigars. The girls labored long hours for pay based on the number of cigars made in a week. The average employee could produce about 2,000 cigars per week, but in 1906, a worker named Mary Slinski rolled a record-setting 5,000 cigars in a single week.

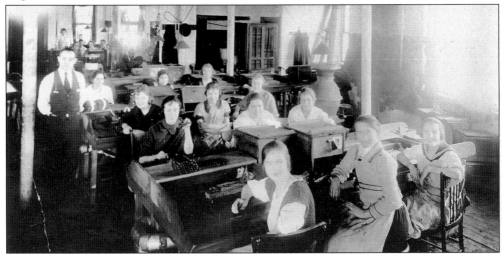

At times, boredom would set in, and cigar production would begin to drop. One manager purchased a piano and hired a young girl to play. The pianist entertained the employees with popular songs from America, Austria-Hungary, Poland, Russia, and other countries that were once home to the workers. The English-speaking girls worked in one room, and the foreign girls worked in the larger adjacent room. The piano would be moved from room to room, and the girls were encouraged to sing along but were cautioned to keep working while they sang. (Courtesy Sophie Szucs.)

In 1896, Gilbert D. Bogart, believing that land at the corner of Semel and Palisade Avenues was rich in fine terra-cotta clay, established the National Brick and Terra Cotta Company. This proved to be a mistake when it was found that the clay was the type used to make common brick and not the more profitable terra-cotta clay. The original buildings of St. Mary's Hospital and the Peoples Bank in Passaic were constructed using bricks made in Garfield. The plant ceased operations in 1900.

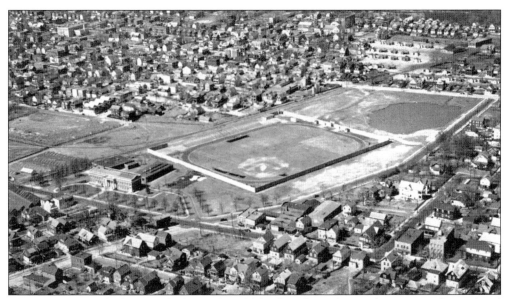

This c. 1940 aerial photograph shows the old brickyard pond near the corner of Semel and Palisade Avenues (where the tennis courts are now). The pond was created when the abandoned clay pit was allowed to fill with water fed by underground springs. For years, it was a favorite swimming and ice-skating spot.

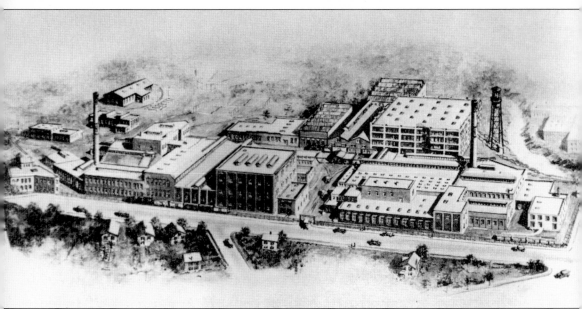

This view shows the Hammerschlaag (later Hammersley) candle-making factory and waxed paper plant as it appeared in 1899. The Hammersly Manufacturing Company was founded in 1877 in New York City and, in 1894, moved to Garfield, where several buildings were erected along the banks of the Saddle River. Sigfried Hammerschlaag, a candle maker, used to buy a fresh fish each Friday at the Fulton Fish Market to be carried home for dinner. Unfortunately, by the time he got home, the paper used to wrap the fish was as wet, limp, and as scaly as the fish was. He tried various types of wrapping paper but could not find one that was satisfactory. On one occasion, he tried dipping wrapping paper in molten candle wax and letting it dry. The following Friday's fish was carried home neatly, and the new wrapping material remained spotless and intact. This was the birth of waxed paper—a product that soon became the backbone of the nation's budding food-packaging industry. (Hammersly 75th anniversary pamphlet, donated by Albert Lewis.)

116

Eight

SPORTS

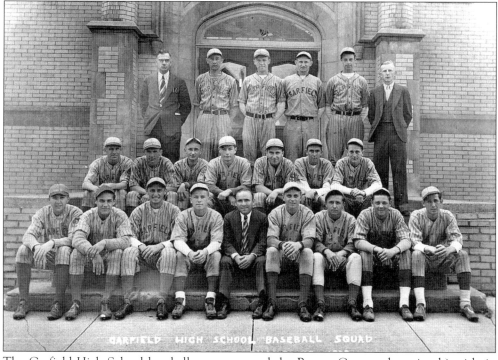

The Garfield High School baseball team captured the Bergen County championship title in 1933. Pictured in photograph are head coach Charles "Chick" Devito (front row, center) and assistant coach Andrew "Red" Simko (back row, far right).

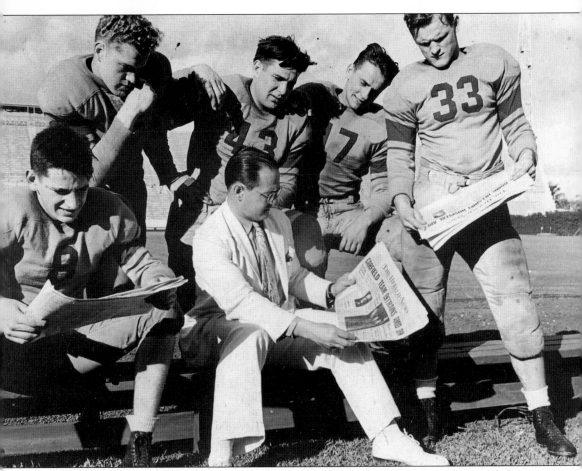

On Christmas night 1939, the Garfield High School Boilermakers football team made history and brought fame to Garfield when they played and defeated Miami High School for the mythical title of national high school football champions. The game was played at the Orange Bowl in Miami, Florida. With the score tied at 13-13 and with only 2 minutes, 18 seconds remaining, Benny Babula stood 20 yards from the goal line and kicked his first career field goal to win the game. This photograph was taken the next day and shows coach Arthur Argauer reading the newspaper headline story of the victory, as players Ed Hintenberger (No. 8), Benny Babula (with hand under chin), Angelo Miranda (No. 43), John Orlowski (No. 17), and John Grembowicz (No. 33) look on.

Members of the 1939 Garfield High School football team cheerleading squad are shown at the school stadium. Provy Conoscenti (center, kneeling), Helen Gazzini (right, kneeling), Vic Liccardi (left, standing), and Mary Laport (center, standing) are the only members that could be identified in the photograph.

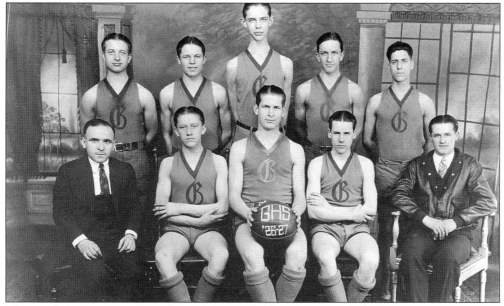

The coach, manager, and members of the Garfield High School basketball team are shown in 1927. From left to right are the following: (front row) coach Charles "Chick" Devito, John Sneft, Pete Chabora, Warren Russell, and manager John Chizeky; (back row) Bob Schwartz, Frank Monash, Herman Hoving, John Kakascik, and Joe Bruno. (Courtesy Frank Monash.)

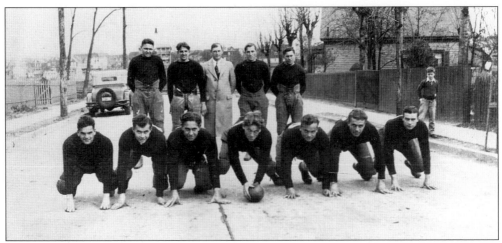

The Garfield Indians Sporting Club was organized in 1926 by 13 young men whose primary purpose was to promote good fellowship and sportsmanship. Taken near their clubhouse on Morris Avenue, this *c.* 1930s photograph includes, from left to right, the following: (front row) Woody Wojcik, Steve Orosz, Ozzie Oswald, Sluggy Jaros, John Trella, Bill Lasky, and John Rozum; (back row) Mike Chizik, Joe Krack, coach "Butch" Frankovic, Joe Szewczyk, and George Maciag. (Courtesy Garfield Indians Sporting Club.)

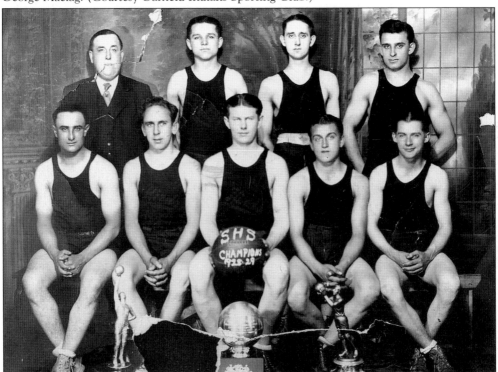

Samuel Hird & Sons Woolen mills sponsored this basketball team, which won the area championship of the 1928–1929 season. The only two players that can be identified are Joseph Szczech (holding ball) and Tony Freschi (seated, far right). A generation later, Joe's sons Paul and Joseph Jr. were outstanding playing baseball and basketball for Garfield High School. (Courtesy Charles Rabolli.)

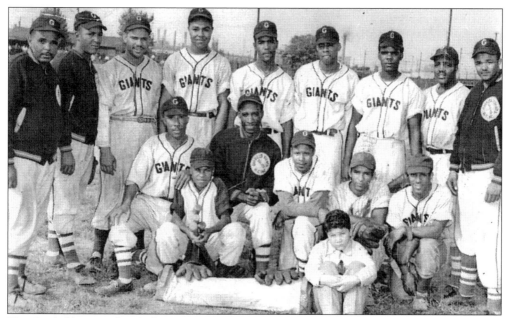

The Garfield Giants baseball team was established in the late 1930s. In 1949, the team won the North Jersey Semi-Professional League Championship. Team members are, from left to right, as follows: (front row) Junior Cooke, Michael Watson Jr., Gene Wright, Cleveland Buggs, Pettis Johnson, and the Nelson brothers; (back row) John Foster (manager), James Watson, Pierce Watson, Albert Campbell, John P. Logan (the first African American to be inducted into the Bergen County Baseball Hall of Fame), Bill Thorton, Otis Robinson, Fred Elam, and Purvis Buggs. (Courtesy John Logan.)

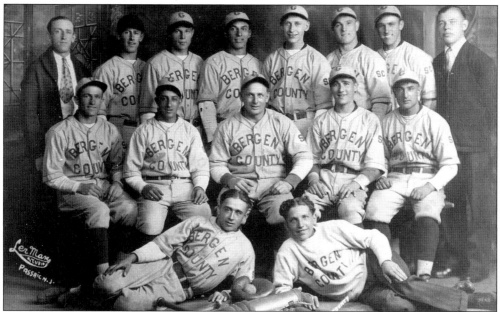

The Lerman Studio of Passaic took this photograph of the Bergen County Sporting Club baseball team after the team won the South Bergen League Championship in 1929. (Courtesy Charles Rabolli.)

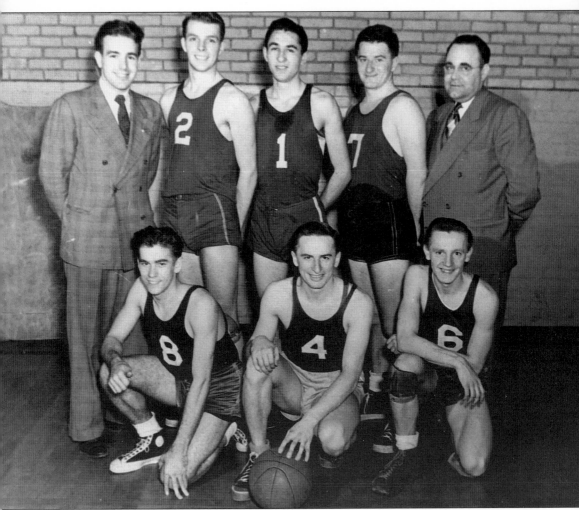

During the financially depressed days of the 1930s, pocket money was scant, but it went a long way if you belonged to the YMCA. In those days, if you were not on a school basketball team or if you were but wanted to play indoor games, a private gym (like Domyon's in Clifton) could be rented by the hour and all players would share the cost. These places typically did not have locker rooms or showers. The gym at the YMCA, however, had locker rooms, showers, a swimming pool, a library, and a busy and organized schedule of classes and events run by qualified trainers and supervisors—all for a nominal membership dues. Seen in this photograph is the YMCA's *c.* 1950 basketball team, flanked by physical director Joseph Fedor (left) and secretary John Pace. (Courtesy the Garfield YMCA.)

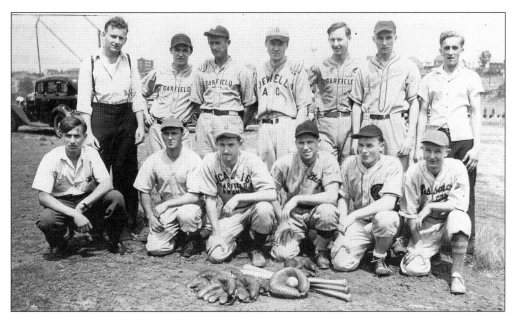

During the early 1920s, there were plenty of empty lots on which to play football, baseball, and other games. Dozens of sandlot teams were formed in many of the local towns. Eventually, amateur and semiprofessional athletic leagues of teams were established throughout the area. This late-1930s photograph shows players of several local teams, including the Garfield Indians and the Jewells.

Charlie Blood Benanti (left) spars with his longtime friend Joey Harrison c. 1930. Between 1927 and 1931, Benanti won an amazing 63 out of 68 professional bouts and held the title of New Jersey lightweight boxing champion. He then wisely left the dangerous sport and opened an Italian-American restaurant and bar at 147 Frederick Street that is now operated by his son Salvatore. (Courtesy Salvatore Benanti.)

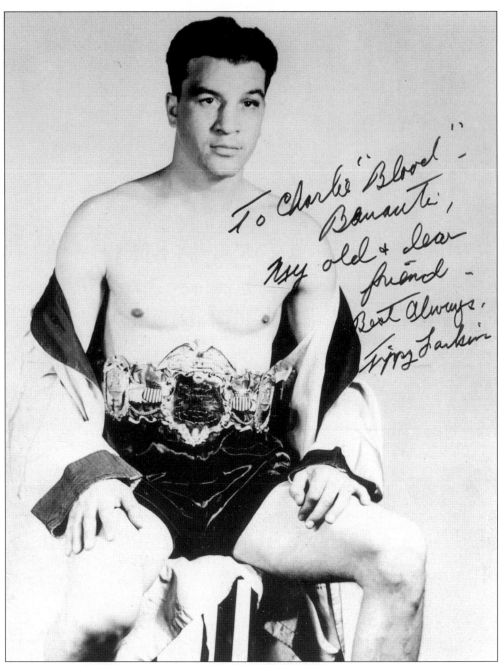

Tippy Larkin is shown with the jewel-studded championship belt awarded to him when he defeated Willie Joyce for the world's junior welterweight title in Boston in 1946. Nicknamed the "Garfield Gunner" because of his quick reactions both in and out of the ring, he grew up at 125 Jewell Street and began boxing professionally in 1935 at age 17. His record at the end of his career, in 1952, was 136 wins and 18 losses with 58 knockouts. Larkin boxed at Madison Square Garden more times than any other boxer in his day. The name Tippy came from the initials of this real name, Antonio (Tony) Pelliteri, and the name Larkin was borrowed from trainer Jack Amato, who once boxed under the name Jack Larkin. (Courtesy Salvatore Benanti.)

Nine

PARADES AND
CELEBRATIONS

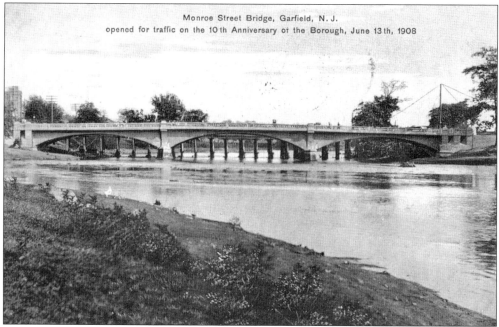

The opening of the new Garfield Bridge at Monroe Street was held in conjunction with the borough's 10th anniversary on June 13, 1908. The parade was stopped at the new bridge, where Mayor John Karl met Mayor Frederick R. Low of Passaic to open the new bridge to the public. Mayor Low then joined the parade as it proceeded to Faber's German Castle Park, where a celebration party was held.

On June 13, 1908, the largest celebration ever held in the borough and one of the largest ever in Bergen County began with a parade of 2,000 participants, including 500 students, each carrying an American flag. The long procession began at 2 p.m. at the corner of Midland Avenue and Grand Street and paraded through every section of the borough. After the parade had ended, a townwide party was held at Faber's German Castle Park on River Drive, near where Faber Place is today.

Members of the American Red Cross turn the corner at Wessington and Belmont Avenues as part of the great parade through the city to welcome home Garfield's own soldiers and sailors who served in World War I. After the parade, citizens attended evening band concerts and were shown open-air movies on the grounds of School No. 6.

MASQUE **AND** **CIVIC**

GRAND VICTORY BALL

OF

Ernest B. Dahnert Association, Inc.

AT EYBER'S BELMONT PARK

FRIDAY EVENING, FEB. 14, 1919

Music by Prof. Biegel's Full Union Bell Orchestra

TWO PRIZES IN GOLD

TICKETS INCLUDING WAR TAX **30 CENTS**

This ticket invitation announces the Grand Victory Ball to be held at Eyber's Belmont Park on the evening of St. Valentine's Day, Friday, February 14, 1919. Members of the Ernest B. Dahnert Association sponsored the event and charged an admission fee of 30¢ (including war tax). The association was founded by a group of civic-minded individuals who were dedicated to carrying on the many improvements made in the city during Dahnert's three terms as mayor.

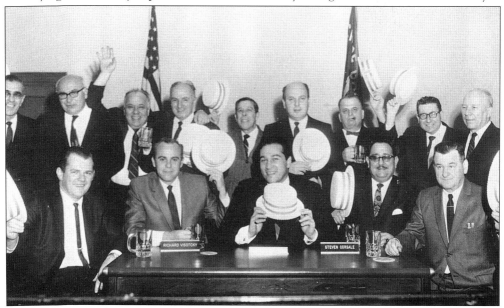

Garfield celebrated its 50th anniversary as a city in 1967. Gathered in this contemporary photograph to kick off the Golden Jubilee Celebration are, from left to right, the following: (front row) Albert Hepp (councilman and committee chairman), Richard Visotsky (councilman), Vincent Rigalosi (mayor), Steve Corsale (councilman and vice chairman), and Paul Reno; (back row) David Casino, William Pelio (city comptroller), Carmen Belli (former mayor), Joseph Kobylarz (former mayor), Henry Sinatra, Walter Fabrici (councilman), Joseph Stefanco (councilman), Arthur Ringele (councilman), and Vaclow Dombal (city clerk).

The 1976 bicentennial celebration in Garfield began on July 3 at the high school stadium. The daylong festivities included a family picnic, games and contests for both young and old, and a spectacular fireworks display in the evening. Then, on July 17, 1976, thousands lined the sidewalks to view a once-in-a-lifetime event as the bicentennial parade made its way through the streets of Garfield. The Garfield Cadets, formerly the Holy Name Cadets, led the first of seven parade divisions. There were 40 floats and 8 specially decorated trucks and cars. This is the first-prize float of the Garfield Amvets approaching the intersection of Semel and Midland Avenues.